TURNER

**Kindly donated in 2018
by Sue Lemasurier,
art student.**

DISCOVERING ART

The Life, Times and Work of the World's Greatest Artists

TURNER

K. E. SULLIVAN

BROCKHAMPTON PRESS

For Mum and Dad, who enabled me to realize my particular vision

The author would like to acknowledge the works of the following Turnerians,
which helped to present a rounded portrait of the enigmatic painter:
Andrew Wilton, Graham Reynolds and Eric Shanes.
I would also like to thank Carey Wells, for enlightened editing,
and Anne Newman, for fastidious proofreading.

First published in Great Britain by Brockhampton Press,
an imprint of The Caxton Publishing Group,
20 Bloomsbury Street, London WC1B 3JH

Reprinted 2004

ISBN 1 84186 0999

Produced by Flame Tree Publishing,
The Long House, Antrobus Road, Chiswick, London W4 5HY
for Brockhampton Press
A Wells/McCreeth/Sullivan Production

Pictures printed courtesy of the Visual Arts Library, London
and the Bridgeman Art Library.
Copyright of the illustrations is acknowledged
to these sources.

Printed and bound by Oriental Press, Dubai

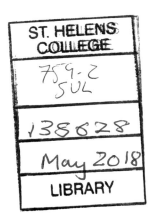

CONTENTS

Turner: Self-Portrait, *c.* 1800 (Tate Gallery, London). This portrait, painted when Turner was twenty-five, shows the artist just after he was accepted as an Associate at the Royal Academy of Art.

CHRONOLOGY

1775 Joseph Mallord William Turner is born in London, on either 23 April or 14 May.

1787 First signed watercolours are finished.
Begins at the Royal Academy Schools.

1790 Turner's first Royal Academy exhibition, he presents *The Archbishop's Palace, Lambeth*.

1791 Exhibits *King John's Palace, Eltham*, and *Sweakley, near Uxbridge, the seat of the Rev. Mr Clarke*, at the Academy. Travels in the West Country.

1793 Receives 'Greater Silver Pallet' from the Royal Society of Arts.

1799 Elected Associate Royal Academician (ARA). First daughter Evelina born.

1800 Mother admitted to Bethlehem Hospital. Exhibits *Dolbadern Castle* and *Caernarvon Castle*, accompanied by his own verse.

1802 Elected Royal Academician (RA). Travels in Switzerland. Second daughter Georgiana born. Exhibits *The Tenth Plague of Egypt*.

1804 Opens own gallery in London. Mother dies. Exhibits *The Passage of Mount St Gothard ...* and *Venus and Adonis*.

1807 Elected Royal Academy Professor of Perspective. Exhibits *A Country Blacksmith Disputing upon the Price of Iron ...* and *The Thames near Windsor: Evening – Men Dragging Nets on Shore*.

1811 First lectures on perspective at the Royal Academy. Travels extensively in Dorset, Devon and Cornwall to make drawings for *Picturesque Views on the Southern Coast of England*.

1819 Walter Fawkes exhibits Turner's watercolours in his London home. Visits Italy. Exhibits *Sun Rising Through Vapour...* and a number of Roman paintings, including *Milan to Venice, Vatican Fragments* and *Naples*.

1828 Last lectures as professor at Royal Academy. Visits Italy. Exhibits *Dido Directing the Equipment of the Fleet ...*, *Boccaccio Relating the Tale of the Birdcage* and *The Lake, Petworth*.

1829 Exhibits *England and Wales* series of watercolours in London. Father dies. Exhibits *Messieurs les Voyageurs on their Return from Italy*

1830 Exhibits last watercolour at the Royal Academy exhibition: *Funeral of Sir Thomas Lawrence, a sketch from memory*. Exhibits *Pilate Washing His Hands*, and *View of Orvieto ...*

1831 Turner's father dies.

1833 Exhibits more *England and Wales* watercolours in London.

1836 Exhibits *Juliet and her Nurse*. Elected to Academy Council, appointed visitor of the Life Academy.

1837 Resigns as Professor of Perspective.

1840 Meets John Ruskin. Travels to Venice. Exhibits *Venice, The Bridge of Sighs*, *Slavers Throwing Overboard the Dead and Dying – Typhoon Coming On* and *Rockets and Blue Lights ...*

1841 Visits Switzerland for the first of three consecutive visits over the next three summers.

1845 Elected interim president of the Royal Academy. Exhibits *Whalers...* and a number of Venice pictures.

1846 Moves to cottage in Chelsea, on the Thames, in London. Exhibits *Queen Mab's Cave* and *The Angel Standing in the Sun*.

1850 Last exhibition at the Royal Academy.

1851 Dies in London, on 19 December.

Opposite:
Venice, Grand Canal, *c.* 1842
(Huntington Library). One of five oil paintings hung at the 1842 Academy exhibition, this work is not representative of the growing formlessness of Turner's later work. He reverts here to classical themes within an exquisitely rendered Venetian landscape.

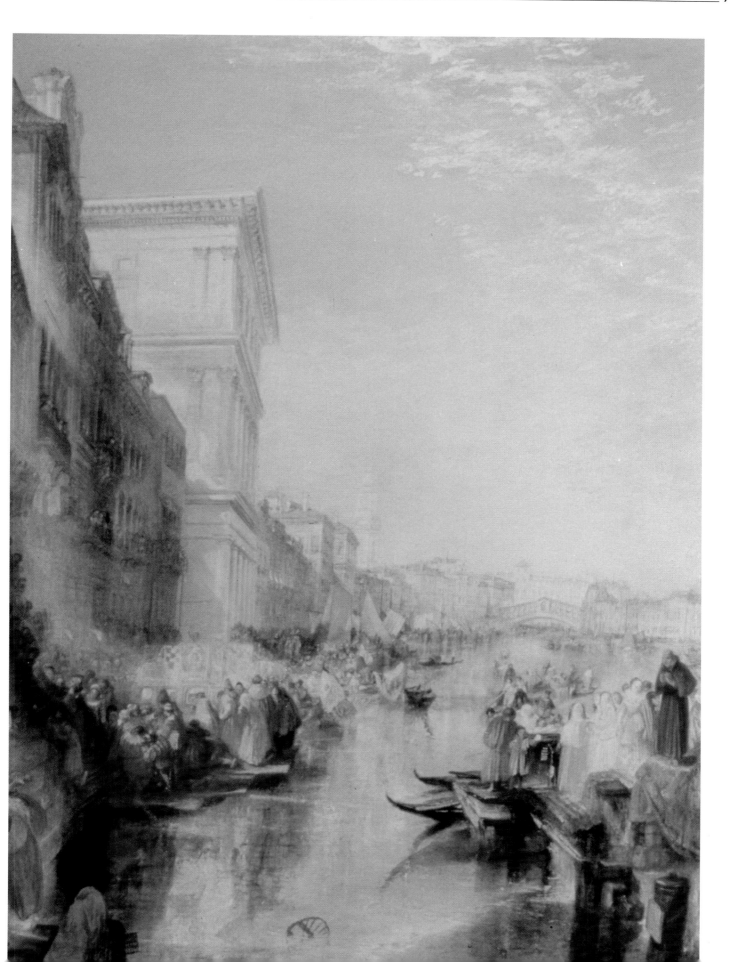

CHAPTER 1

The Early Years (1775-1800)

According to the Register, Joseph Mallord William Turner was born to William Turner, a London wigmaker, and his wife, Mary Turner, on 14 May 1775. According to Joseph Mallord William Turner, he was born on 23 April of that same year, coincidentally and certainly more poetically, the birthday of both Shakespeare and St George.

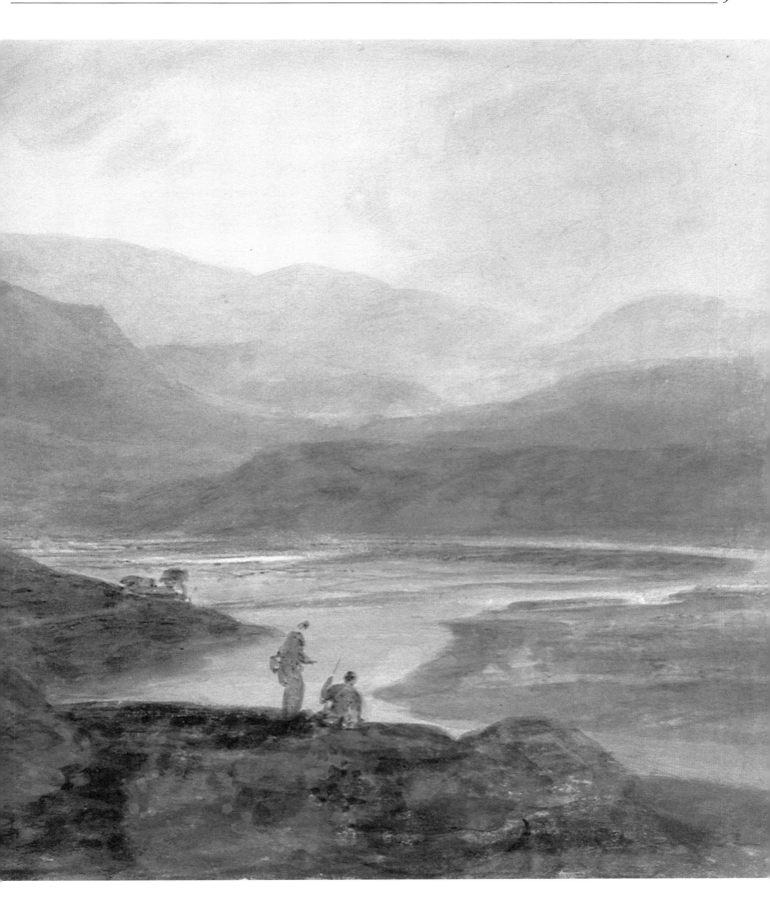

Turner was born in London, in the heart of Covent Garden, a stone's throw from the River Thames. For the rest of his life he would make his home by its banks, fascinated by its waters and obsessed by the effect of light and reflection on its surface and on the vapours which curled up and hung above them. The Thames was a working river, and the sterns of ships and rigged boats thrust their way through the mists and the smoke of London as they went about their toil. They fixed an impression which seduced the young artist: the vision of water and boats, of light splayed through fogs and reflected on mists, of man in nature, compelled him to take this as the subject or setting for almost all of his work.

Covent Garden in the late eighteenth century was a bustling fruit and flower market. At its edges was the barbershop owned by Turner's father. Barbershops then were social places, frequented as often for a drink and a chat as they were for a haircut. William Turner hung the young William Turner's work on the walls of his shop, and many of his early sketches were sold from its windows. It was the first forum for Turner's work and his proud father encouraged the local community to take note. It was unusual, in those days, for art as a career to be encouraged among the working classes, but Turner's father was matter of fact about his son's talents and remarked constantly to enquiring patrons, 'William is going to be a painter.'

Turner's father was a garrulous, good-humoured man, firmly acquainted with poverty and quite desperate to escape its throes. He instilled in his son a sharp financial acumen which led in later life to the painter being deemed mean and miserly. The Turner home was not a happy place. Turner's mother suffered from mental illness, which was compounded when Turner's younger sister Mary Anne, born in 1778, died at the age of seven. Walter Thornbury, in *The Life of J.M.W. Turner*, wrote:

> ... *report proclaims her to have been a person of ungovernable temper, and to have led her husband a sad life. In stature, like her son, she was below the average height. In the latter part of her life she was insane and in confinement. Turner might have inherited from her his melancholy turn of mind.*

Turner's father was unswervingly loyal to his son, but his wife's illness meant that he had little time for the youth and Turner was sent away to live with relatives for long periods of time throughout most of his childhood. He lived with a butcher uncle in Brentford, Middlesex, where he attended a free school as a day boarder, and later moved to Margate, Kent, to stay with a relative on his mother's side. When he returned to London it was to work as a draughtsman in the offices of various architects, and in 1789 he worked for Thomas Malton, who

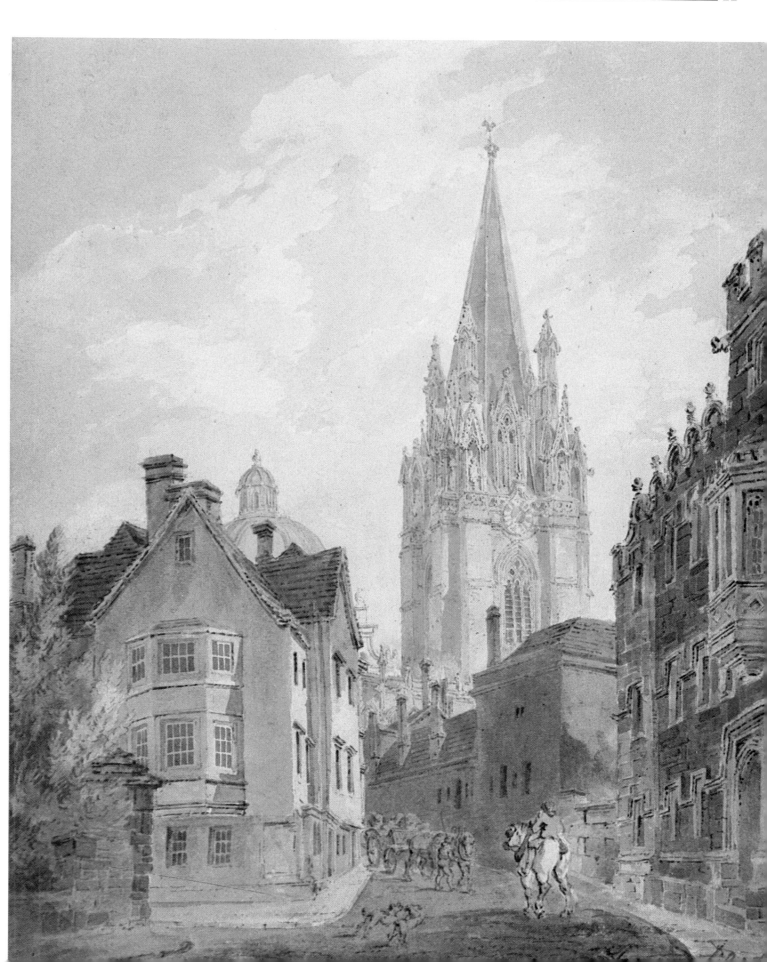

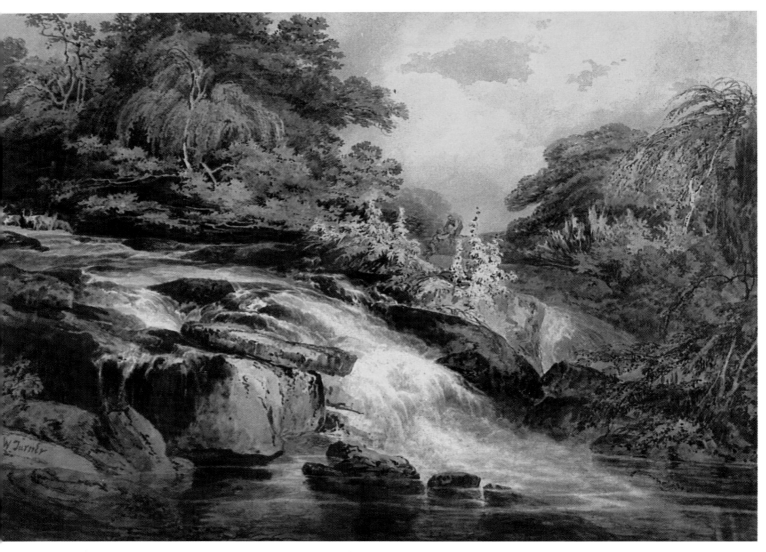

The Cascade, Hampton Court, Herefordshire, 1795 (Victoria & Albert Museum, London). Throughout his career, Turner was fascinated by water, and took every opportunity to capture its elusive quality. Here, at Hampton Court, he integrates it in a somewhat idealized landscape.

was well known for his exquisite representations of London buildings. Turner was a born imitator, and he quickly absorbed and adopted Malton's technique, which set him in good store for admission to the Royal Academy Schools.

Turner was only fourteen when he was accepted to the Academy Schools as a probationer, and the Royal Academy was to become the centre of his world for the remainder of his life. It was, at the time, the only art school in England and its president was the formidable Sir Joshua Reynolds, who preached an idealization of academic art as it had developed from the Italian Renaissance. Eric Shanes in *Turner* writes: 'This was through the doctrine of "poetic painting" which held that painting is as a humanistic discipline akin to poetry and that it should concern itself not with the arbitrariness of experience but with universals of behaviour and form.'

Painting was not yet taught at the Academy and Turner studied drawing from plaster casts and then, when he was ready, from nude

models. Turner had spent much of his childhood in London, and in English villages, quite far, really, from the natural world which he would paint over and over again. Graham Reynolds in *Turner*, writes:

> *... Turner did not really look to most natural objects with the attention of one who had grown up with them. He could if he wished focus his remarkable power of vision on trees and plants ... In the vast range of his sketches there are remarkably few studies of such individual objects as weeds or flowers ... the natural phenomenon which impressed him most as a boy and which he painted all his life was that characteristically urban one, the play of light through smoke, fog or mist.*

It was at the Academy Schools that Turner met William Frederick Wells, a landscape colourist who became a close friend, and who offered a second home when Turner's mother sank into an incurable mental illness.

When the situation at home became unbearable, Turner spent increasing amounts of time visiting family and friends around the country. He was, however, already devoted to art and is remembered as being obsessive and unusually fastidious about his work. Ann Dart, a niece of the Narraway family, with whom Turner stayed in 1791 and 1792, recalls Turner as being:

> *... not like young people in general, he was singular and very silent, seemed exclusively devoted to his drawing, and would not go into society, did not like 'plays', and though my uncle and cousins were very fond of music, he would take no part, and had for music no talent.*

She went on to call him:

> *... a plain uninteresting youth both in manners and appearance, he was very careless and slovenly in his dress ... and was anything but a nice looking young man ... He would talk of nothing but his drawings, and the places to which he should go for sketching. He seemed an uneducated youth ...*

Turner was only sixteen, but he was sullenly mature and clearly absorbed in the career which would capture his attention, his spirit and all of his enthusiasms for the rest of his life. Turner may not have had much to say on subjects which were not directly linked to his art, but he was not always the silent, sour presence that many suggest. Clara Wells, William's daughter, recalls a lively, friendly character in Turner, an image which does not dominate most recollections: 'Of all

the light-hearted, merry creatures I ever knew, Turner was the most so; and the laughter and fun that abounded when he was an inmate in our cottage was inconceivable, particularly with the juvenile members of the family.'

The portrait of Turner as an uneducated man was largely true. Art was his school and he learned through experimentation and emulation. He loved poetry and read a great deal, which was to become increasingly obvious in the nature of the subjects of his work, but he maintained a rather uncouth appearance, delighting not in fine clothing, nor food and wines. He cultivated a kind of aloofness which reeked more of social inadequacy than deliberate indifference or shyness.

But whatever people thought of Turner's manner and behaviour, his talent was undeniable. He travelled extensively around the English countryside throughout these years, filling sketchbooks with scenes upon which he would base later works. Turner's astonishing visual memory allowed him to take down just the outlines, the fragmented composition of a scene, and bring it alive even decades later. He never painted exactly what he saw; indeed, he idealized nature to such an extent that a Turner landscape could be made up of any number of the best elements from a dozen or so scenes. His landscapes were lyrical representations of what he believed nature could be rather than faithful reproductions of what existed. They are beautiful because they are composed of beauteous components; they are nature at her finest in that only the fine details of nature have been painted.

Landscape painting was generally frowned upon by the critical establishment, being very much the poor relation to portraiture and genre art, and Sir Joshua Reynolds encouraged this attitude in the halls of the Academy. He felt that landscape painting was 'simple-minded' because it said nothing about the human condition. But Reynolds did find favour with the technique of Claude Lorraine (called Claude), who painted a scene not as he saw it, but as a fictitious combination of ideal features from a number of places. Eric Shanes points out that Turner adopted Reynold's synthesizing practice, and would often 'freely alter or omit anything in a particular scene that did not accord with his imaginative demands – so that sometimes his landscapes bore little resemblance to the actuality of a place.'

Turner's interpretation of architecture was exceptional, likely because of his training as a draughtsman. He seemed to have an instinctive feel for the fundamental construction of things, what Shanes calls a 'total comprehension of the underlying dynamics of manmade structure, over and above a grasp of their surface appearances'. He looked upon nature with the same eye – believing that natural architecture was built upon the same basic laws, that a 'metaphysical geometry underlies both'. The 1790s marked a period of prolific output and extraordinary experimentation.

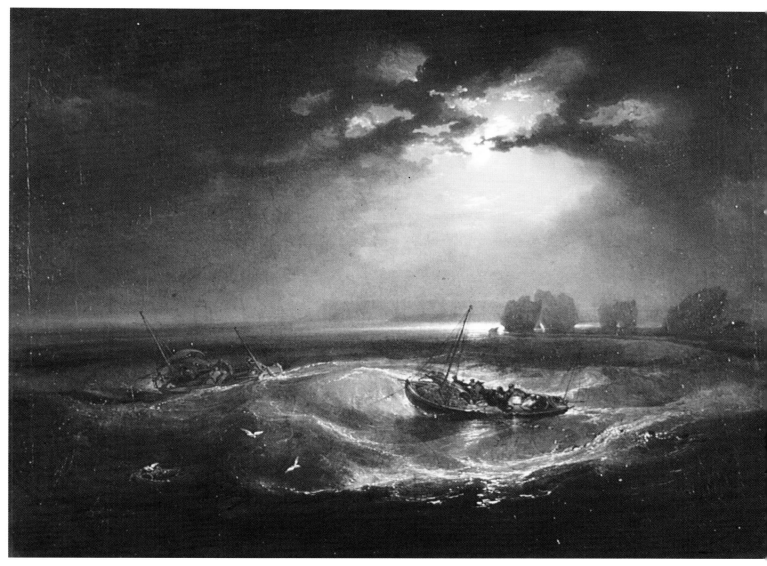

It's difficult to rationalize the fact that Turner was, throughout this period, still a student, and rather poor. His travels were based around trips to family friends and associates, and because of his mother's condition, he was welcomed in all their households. From 1791 he made the first of his sketching tours, travelling lightly and at very little expense, although he was now making some money from newly acquired patrons, and he filled a number of sketchbooks with drawings mainly, but also the occasional watercolour, which he would transform into paintings in his studio.

Turner's education was paid for by various odd jobs, but shortly after his first exhibition in 1790 at the Royal Academy, he had begun to sell works. Turner's first Academy-hung painting was *The Archbishop's Palace, Lambeth*. It was his second attempt at a theme which he had begun a year earlier. In 1793, at just seventeen, he was awarded the 'Greater Silver Pallet' by the Royal Society of Arts, and he had acquired

Fishermen at Sea, 1795 (Tate Gallery, London). One of Turner's early oil paintings, this one is indicative of the extent to which he was influenced by the Masters, like de Loutherbourg. But Turner's ability to perceive and recreate light was unprecedented and influenced a whole new school of artists.

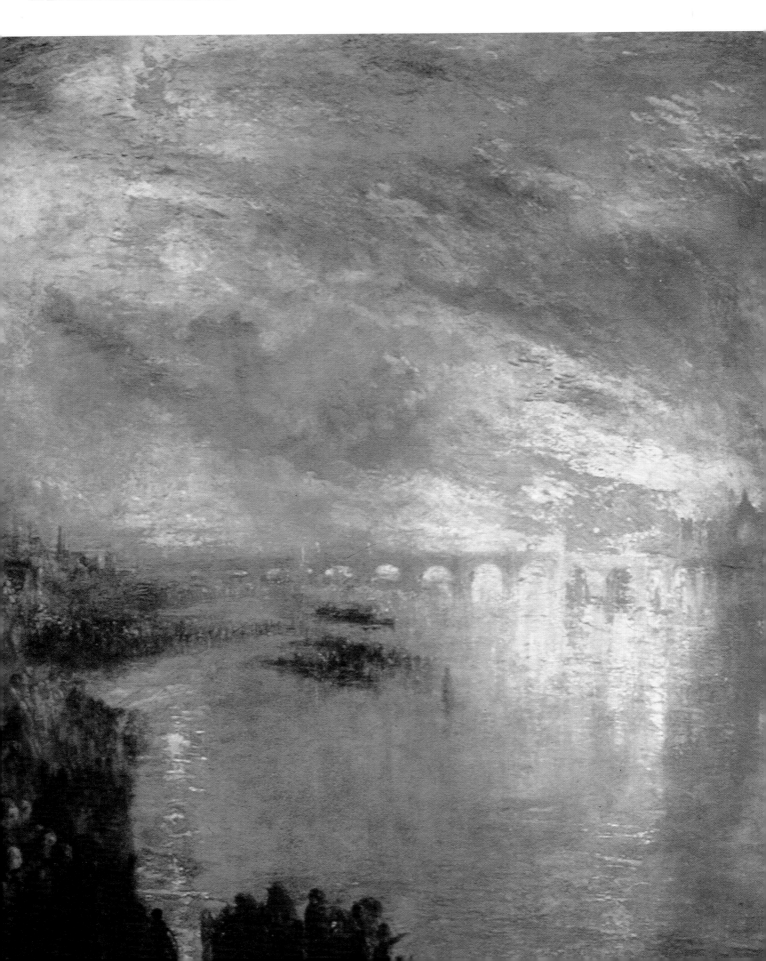

The Burning Of The Houses Of Lords And Commons, October 16, 1834, 1835 (Cleveland Museum of Art). Turner painted two versions of the great fire of 1834, the smoke and flames against the evening sky exciting his imagination. He painted hastily, and one of the paintings was finished in just a day.

a reputation which allowed him to give private lessons in order to contribute to his upkeep.

From 1794 to 1797 he had a casual evening job working at the house of Dr Thomas Monro, who had set up his home as a kind of informal training school for artists, called the 'Monro Academy'. Turner's job was to tint and colour sketches and prints designed by or copied from others. The fee for this was three shillings a night, plus a rather splendid supper of oysters. He worked here with the landscape artist Thomas Girtin, who was to have an enormous impact on Turner's work for the remainder of his life. Many of his contemporaries considered Monro to be a selfless man, dedicating himself to the enlightenment of young artists, but Turner's father, and others, felt that he was, in fact, pursuing their education for his own benefit. Indeed, through these talented young men, he created his own collection of copies which he could never have afforded to purchase.

Some of these copies included the works of John Robert Cozens, the forerunner of the English Romantic landscape movement. Cozens had been declared insane in 1794 and was under Dr Monro's care in the Bethlehem Hospital in London (the same hospital where Turner's mother was eventually sent, and where she would die). The relationship between Girtin and Turner thrived under the challenge of recreating Cozens' works. Graham Reynolds describes their partnership:

> *The resulting drawings were reinterpretations of Cozens, but in a less melancholy key. They were bold, fresh, decisive. Turner learned not only from them but from the stimulus of working in rivalry with his most gifted contemporary. Girtin, who had ... studied at the fount of the new topographical trends, was able to import much, and for a time the styles of the two men became similar.*

Turner was much better known than Girtin, and there is some suggestion that his mastery of the landscape was much more accomplished. However, the two men fed off one another and Turner was undoubtedly influenced by Girtin both in style and in coloration. Other influences throughout these early years include Thomas Gainsborough, the English painter with a penchant for Dutch landscapes. Gainsborough's landscapes were only partly dependent on drawings from nature, like Turner's own; Gainsborough would design 'natural' landscapes, using rocks, moss, fragments of glass and branches of trees in the studio. His paintings depict contemporary country life, with a style that was decidedly influenced by the Rococo movement. Turner found an affinity with the great painter, who was one of the few landscape artists of the eighteenth century to receive academic acclaim. Michael Angelo Rooker, one of the eighteenth

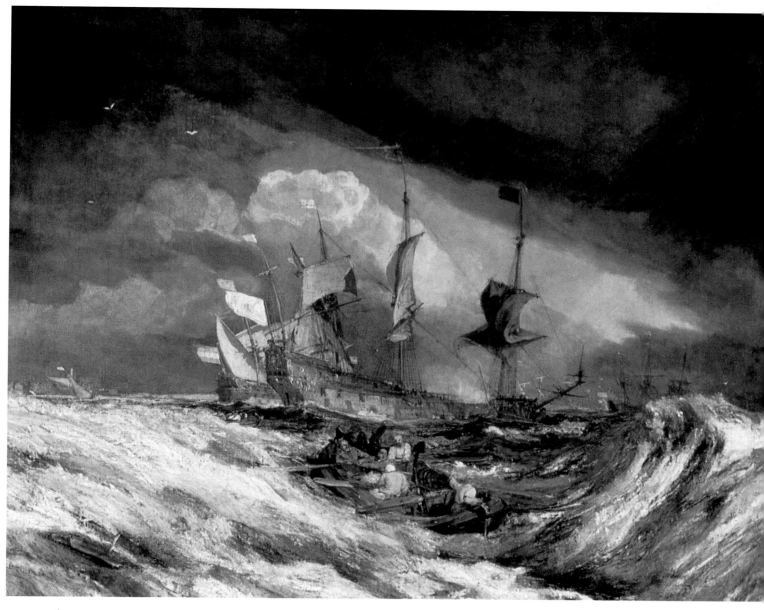

century's most ambitious topographers, was another strong influence; his use of tone changed Turner's approach to coloration, an effect which was represented in most of Turner's *oeuvre*.

Turner worked mainly in watercolours, exhibiting a swelling number of paintings at the Royal Academy. There were five water-colours in 1794, eight in 1795, ten in 1796, and in that final year he also exhibited his first oil painting, *Fishermen at Sea.* His paintings were based on the startling landscapes and architecture of his travels, partic-ularly in Wales. He imbues his architecture with a contemporary but never sentimentalized romanticism, and in these early days was considered very much a precursor to the English Romantics, adopting their winsome and dark subject matter and enhancing it with his own sensitive analysis of structure and composition.

Boats Carrying Anchors to Dutch Men of War, 1804 (Corcoran Art Gallery, Washington). The influence of the Dutch marine painters was evident in much of Turner's work; in particular, the paintings of Willem van de Velde the younger inspired at least one Turner painting of a boat on a tempestuous sea.

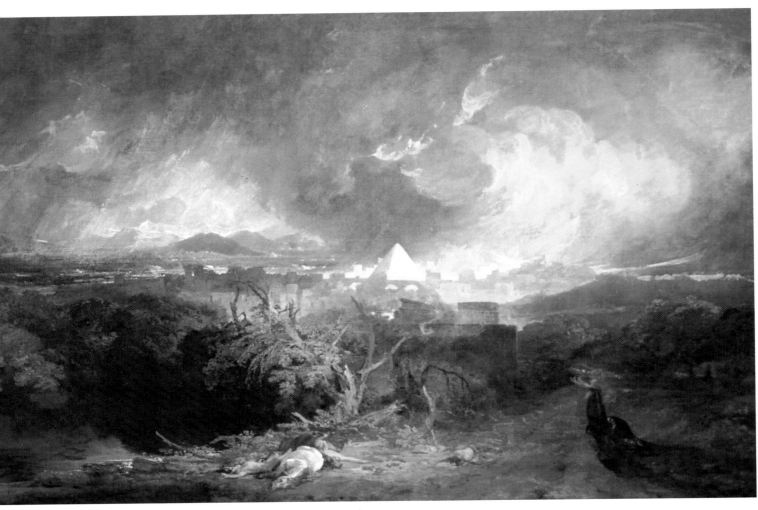

The Fifth Plague of Egypt, 1800
(Indianapolis Museum of Art). Turner
painted this shortly after being elected
as Associate to the Academy. In fact, the
theme is the seventh plague, since the
quote accompanying the painting was:
'The Lord sent thunder and hail and the
fire ran along the ground.'

Fishermen at Sea illustrated Turner's natural gifts for painting in
any medium. As easily as he had mastered watercolour, he became
proficient in oils, lending the medium a fluidity and incandescent
quality that few artists were able to achieve. Yet the splendour of
Fishermen at Sea was not its unique interpretation of oils, but rather his
extraordinary depiction of the sea. Eric Shanes discusses the signifi-
cance of this work:

> ... we can equally detect Turner's total apprehension of the funda-
> mental of hydrodynamics. Fishermen at Sea of 1796 demonstrates
> how intently the painter had already studied wave formation,
> reflectivity and the underlying motion of the sea. From this time
> onwards, his depiction of the sea would become ever more masterly,
> soon achieving a mimetic and expressive power that is unrivalled in
> the history of marine painting. There have been and are many
> marine painters who have gone beyond Turner in the degree of pho-
> tographic realism ... but none of them has come within miles ... of
> his expression of the behaviour of water.

Anthony Pasquin, an important contemporary critic, wrote in *A Critical Guide to the Exhibition of the Royal Academy for 1796*: 'We recommend this piece, which hangs in the Ante-room, to the consideration of the judicious ... we do not hesitate in affirming that this is one of the greatest proofs of an original mind, in the present pictorial display.'

Fishermen at Sea reflected the influence of the French marine painter Joseph Vernet, and it has been suggested that the shaping of the cloud is evidence of Philippe Jacques de Loutherbourg's effect on the young painter's work. De Loutherbourg was a superb landscape painter, educated at Strasbourg and already a member of the French Academy when he arrived in Britain in 1771. He is said to have commented that 'no English landscape painter needed foreign travel to collect grand prototypes for his study'. His technique was often undertaken in Turner's early work. The portrayal of the night sky, in *Fishermen at Sea*, however, is a superb and unparalleled rendering, placing Turner in a class of painters he had before this only hoped to join. This painting is the epitome of early Turner style, and reflected the hard work and constant motivation which had begun to refine his ideology.

Turner continued to study art, even in his own time. It became his life and he had little time for anything else. Even when he was not under the roof of the Academy he was experimenting, pushing himself further, rendering another nuance of air, or water, or atmosphere. He was obsessive and he had the genius to recreate what many others did not even have the vision to recognize. He set himself artistic challenges, working in different mediums, on different paper, changing his colours, his approach to tonality and composition. He was one of the most prolific artists in English history, and he approached his work without sentimentality. Claude Oscar Monet, famous for his Impressionist masterpieces, said in 1893, 'Anyone who says he has finished a canvas is terribly arrogant.' Turner had no such qualms. When his painting was finished he walked away from it and rarely returned to retouch. In fact, his varnishing process was undertaken at such speed there was often little opportunity to make alterations. Later in his career he was watched as he completed a painting in the halls of the Academy. It was said that he painted *The Burning of the Houses of Lords*

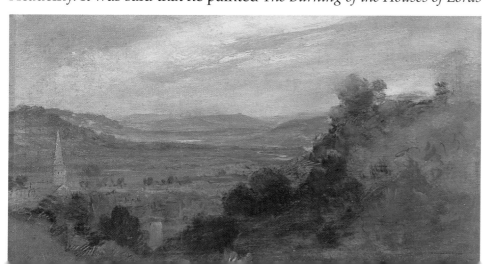

Godalming from the South, *c.* **1807** (Tate Gallery, London). Turner's travels around England, Scotland and Wales in the late eighteenth century provided him with sketches on which he based whole or parts of paintings for the next decades.

and Commons (1835) in only one day. When he finished, he stood back and, as it was explained in the *Art Journal* of 1860:

> *Turner gathered his tools together, put them into and shut up the box, and then, with his face still turned to the wall, and at the same distance from it, went sidelong off, without speaking a word to anybody, and when he came to the staircase, in the centre of the room, hurried down as fast as he could. All looked with a half-wondering smile, and Maclise [a contemporary], who stood near, remarked, 'There, that's masterly, he does not stop to look at this work; he knows it is done and he is off.'*

Art was changing in the late eighteenth century. In 1798, the Academy allowed, for the first time, artists to include quotations, of poetry, literature or other sources, alongside their work, and Turner immediately rose to the challenge. He began a new exhaustive study of the inter-relationship between poetry and painting, allowing his work to lend a visual element to some snippets of poetry, revelling in the concurrent symbolism which existed. Then, two years later, he went further, using some particularly vivid and metaphorically fertile works of poetry to make richer and fundamentally deeper the message of his own painting. He grew excited by the possibilities of imagery in art, and its co-existence with literature. He studied in depth the work of Claude Lorraine, the superb landscape painter whose work had been much touted by Sir Joshua Reynolds as the ideal for the genre. Turner was greatly moved by the older painter's works. Unusually for him, he responded with despair when he saw a Claude seascape. George Jones, a colleague and friend of Turner's, in *Recollections of J.M.W. Turner*, recounted Turner's reaction to the painting, *Seaport with the Embarkation of the Queen of Sheba* (1648):

> *When Turner was very young he went to see Angerstein's pictures. Angerstein came into the room while the young painter was looking at the Sea Port by Claude, and spoke to him. Turner was awkward, agitated, and burst into tears. Mr Angerstein enquired to cause and pressed for an answer, when Turner said passionately, 'Because I shall never be able to paint anything like that picture.'*

This story is made all the more moving when one considers the fact that several decades later Turner stood before some of the world's greatest masterpieces in galleries and museums across Europe, taking notes, studying structure, composition and technique, shaking his head with awe at the great things that painting could become, and all the while trusting his own ability, his innate capability to match them one day.

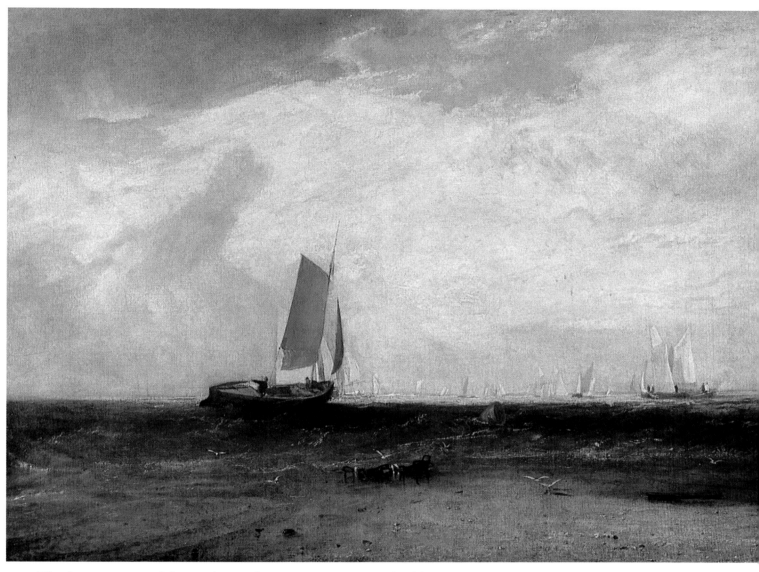

The latter years of the eighteenth century were marked by enormous professional and personal development in Turner's life. His new oil paintings explored extraordinary new experiments with tone and aerial perspective and his subjects were drawn from far across the English and Welsh countryside. His watercolours were similarly accomplished, and works like *East View of the Gothic Abbey (Noon) ...* and *Harewood House from the South East,* are masterful, his control of light evident even at this early stage in his career.

Around this time, Turner also painted some spectacular views of Welsh castles, such as *Caernarvon Castle,* in 1799, a watercolour imbued with the same tonal values and composition as Claude's work, and *Harlech* and *Dolbadern,* the last of which was exhibited at the Royal Academy in 1800. At the age of twenty-four he also waited to hear if he had been elected to one of the two associate positions at the Academy. As it transpired, he was narrowly beaten for both, but

Bly-the-Sand, Tide Setting In, *c.* **1809** (Tate Gallery, London). An English seascape, this painting provides an expanse of sky in which Turner is able to render the light in subtle masses of soft colour. His work would later influence the Impressionists, who based some of their ideology on his use of colour to present atmosphere.

the support of many of the Academicians encouraged him and he felt he had found a new home there. It wouldn't be long before he was welcomed officially.

Turner's family home had by now fallen apart. His mother, in the last years of her life at their house in Maiden Lane, Covent Garden, had become increasingly ill, behaving in a distressing and erratic manner. The time had come for Turner to set up house himself. He acquired rooms at 64 Harley Street, originally with a landscape painter, John Thomas Serres, but the arrangement was short-lived and Turner stayed on by himself.

Intriguingly, Turner also took up with a woman during this time. Mrs Sarah Danby was the widow of the composer John Danby who had died in May, 1798, and Turner appears to have begun a relationship with her shortly after this date, subsequently producing two daughters to join the four children she had already. He met her at the glee clubs in London, through which Danby had worked, and

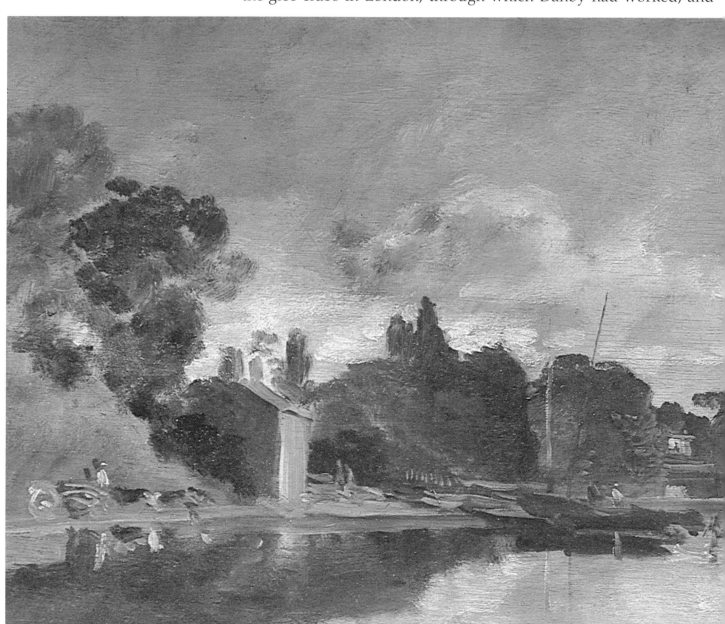

although it has been proclaimed that Turner had no musical talent, he clearly enjoyed these evenings, and the relationship they spawned. He did not choose to live with Sarah, and his two small daughters, Evelina and Georgiana, rigorously keeping private his personal life, and there is no note of their existence made in any of his sketchbooks, or among his belongings.

Turner was an intensely private, dedicated man. He lived for his craft, which filled a hole in a life that had been rent by domestic unhappiness. He was deeply insecure, and outrageously defensive. He lacked social graces because he had not the confidence or the skill to engage in normal discourse, and because of that he was often unable to get across his points, to make himself clear, to put across an argument.

With a paintbrush, words were unnecessary. He created a whole new vocabulary with his art, and found that through it he could communicate. Suddenly everyone took note. With this revelation came the confidence to become his own man.

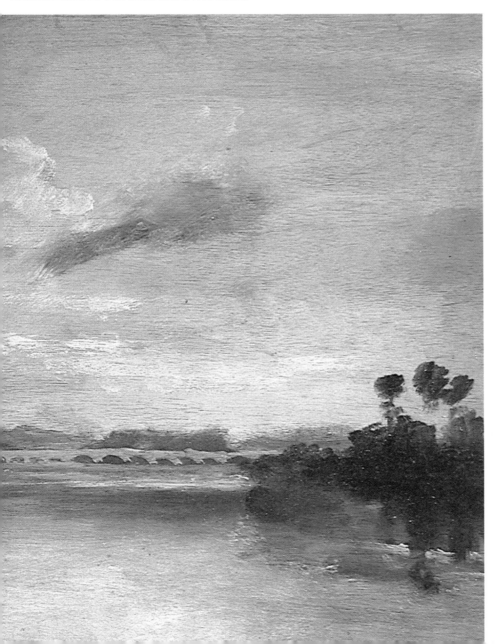

The Thames near Walton Bridge, *c.* **1807** (Tate Gallery, London). The Thames was a source of inspiration for Turner throughout his life; he worked it in pen and ink, watercolours and oils, and later used many of these pictures in his collections of etchings.

CHAPTER 2

Academy Man (1801-1820)

J.M.W. Turner was elected to the position of Associate of the Royal Academy at the age of only twenty-four, and with that position his character changed completely.

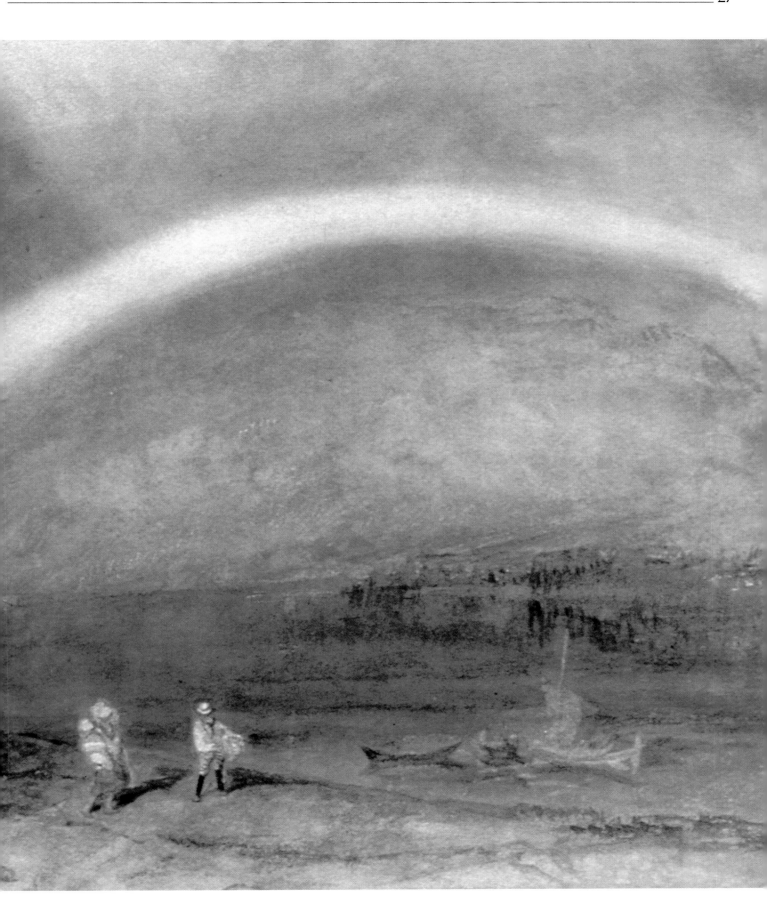

The Academy spelled success to Turner. As soon as he achieved its recognition he began to behave in a manner which befitted his new status. His shy, rather humble character was transformed by a more aggressive and opinionated temperament. Turner had always been highly strung, but his lack of self-confidence and his humility had kept in check his irrational behaviour. Following his Associateship in 1799, and his election to full Academician on 12 February 1802, he became an altogether different proposition. Turner had been elected to the Academy following the death of Francis Wheatley the previous year, and his diploma work comprised the stunning *Dolbadern Castle*. The position of Academician was enormously prestigious, and meant that Turner's work would automatically be exhibited each year, without his having to submit to the rigorous selection process.

Turner was bound to have been grateful for his new position, but he blustered with new self-confidence, and when he was advised by his colleague Thomas Stothard to thank the Academicians who had voted for him, he replied that he would 'do nothing of the kind'. He told Stothard that if they had not been satisfied with his pictures, they would not have elected him. Why, then, should he thank them? 'Why thank a man for performing a simple duty?'

Throughout most of his life Turner felt self-conscious about his lowly upbringing, particularly among the largely cultured and educated members of the Academy. Much of his surliness came from his acute discomfort among this company, and his belief that he was inadequate in some way. But he was confident about his painting, and he allowed it to forge a new path among these establishment men – a path on which he marched decisively through their midst. A fellow Academician, Joseph Farington, said of him, 'His manners, so presumptive and arrogant, were spoken of with great disgust' and indeed this arrogance was partly responsible for a split which occurred within the administration of the Academy shortly after his election.

It must be made clear from the outset that Turner was not unintelligent; in fact, his mind was clever, sharp and assertive. His disability was his social and verbal impotence. In situations in which he felt comfortable, he could be amusing and keenly intelligent, able to discuss a wide range of subjects. The great landscape painter, John Constable, with whom he had a stormy relationship, said of him, 'I was a good deal entertained with [him]. I always expected to find him what I did. He has a wonderful range of mind.'

The dissension in the Academy was the result of a split in opinion about whether the King (George IV) should be allowed to intervene in Academy affairs. The President of the Academy, following the death of Sir Joshua Reynolds, was Benjamin West, who had a good relationship with the Court. Colleagues, some of whom were jealous, but many of

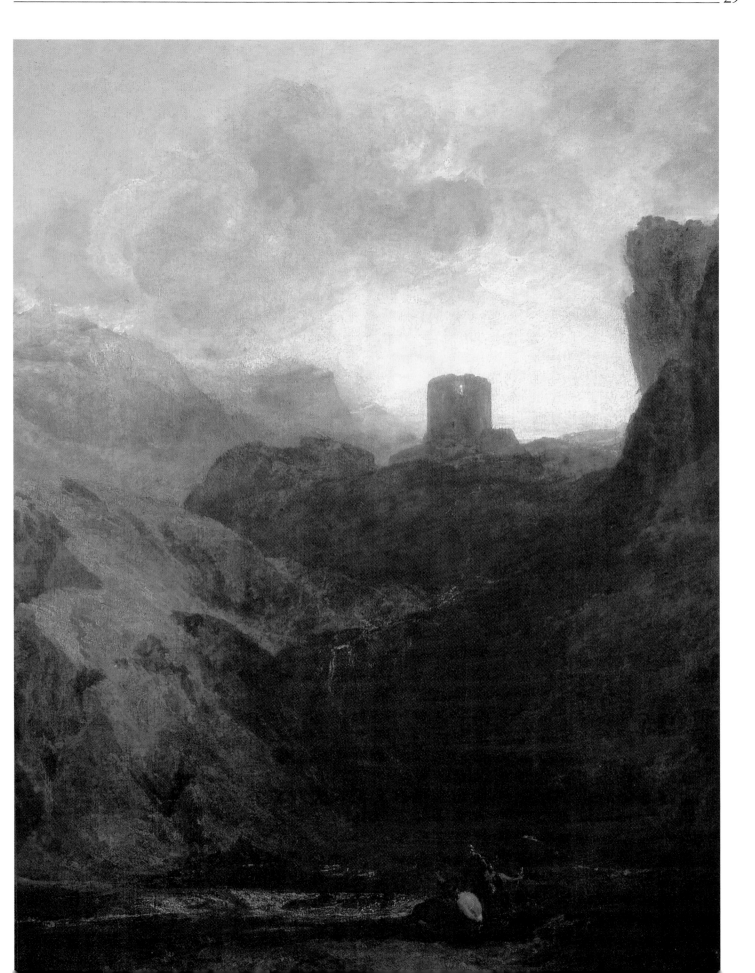

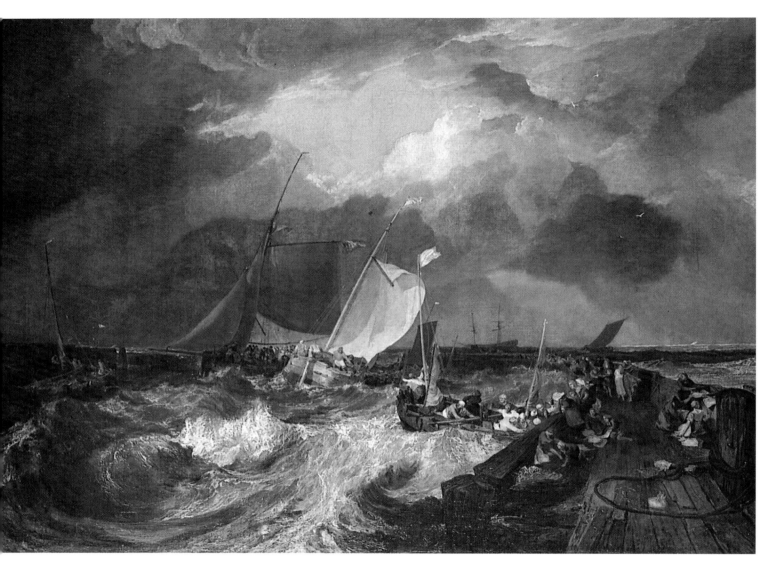

Calais Pier, with French Poissards Preparing for Sea: An English Packet Arriving, 1803 (National Gallery, London). Painted following his study of the Masters at the Louvre in Paris, this work is representative of Ruysdael's influence on his composition and style.

whom were simply discomfited by West's meagre vision, sought to discharge his favour and thereby oust him from his position within the Academy. Turner sided with West, as did many of the Academicians. But there was a rising group within the Academy who supported the other side. By May, 1804, Turner had fallen out with a number of his colleagues, and the atmosphere at the Academy was such that he needed refuge from it. It was at this time that he decided to open a gallery, in London's Harley Street, in order to exhibit and sell his own work. This seemed a preposterously egotistical stance for a man who was not yet thirty and it did not improve his position within the Academy.

He had recently had some notable successes with *Dutch boats in a Gale ...* (1801) and *Fishermen upon a Lee-shore ...* (1802). Andrew Wilton, in *Turner*, points out that these works demonstrate clearly that Turner's gifts were as much for the abstract and contemplative as for the sublime and dramatic. He seemed able to turn his hand to an extraordinary breadth of styles, imbuing nature in his works with passionate

elegance. He visited Scotland, filling several sketchbooks with pencil drawings and a number of large colour studies, from which he later prepared his watercolours.

He also paid his first trip to Europe, made possible by the tentative Amiens treaty between Britain and France of 1802, and he took the opportunity, like many of his fellow painters, to witness at first hand the great masterpieces in the Louvre. In Paris he studied the works of classical painters like Poussin, Titian, and Italian Masters, like Raphael, Correggio, Guercino and Comenichino. He sketched and made notes on the use of colour in the paintings and the manner in which it could be used to convey emotion. Graham Reynolds, in *Turner*, wrote:

> *It shows the strength of his powers of assimilation that when presented with such a visual banquet as the Louvre then offered he did not either despair or become confused in his aim. He sat down to analyze the twenty or thirty works which at that stage meant most to his development, and to concentrate on those aspects which were to be of more lasting concern: the choice of subjects which could receive epic treatment and the successful use of colour*

Ploughing up Turnips, near Slough, *c.* **1809** (Tate Gallery, London). Turner adapted a boat to accommodate his paints and he travelled up and down the Thames, painting directly from nature instead of producing sketches for later use.

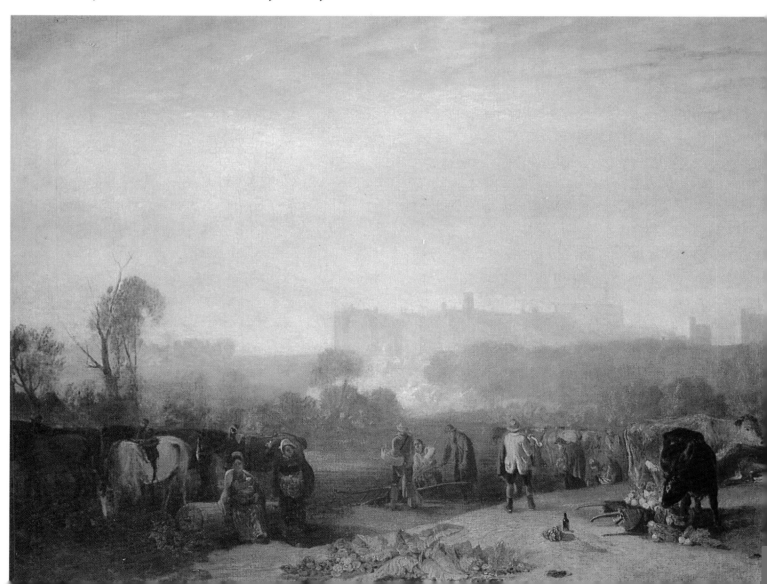

The Louvre was a veritable feast for the English painters. The National Gallery had not yet been opened in England and there was no great collection of the nation's art or indeed of the Masters there at all. The Academicians flocked to Paris, with the result that English painting was imbibed with a new sense of its own potential.

Turner also painted the port at Calais, in France, and travelled to Switzerland where he made over four hundred drawings in six sketchbooks. On his return he remarked to Farington that he had suffered 'much fatigue from walking, and often experienced bad food and lodgings. The weather was very fine. He saw very fine Thunder Storms among the Mountains.' Turner was to call upon these dramatic sketches for the next seventeen years, when he was able to return to Switzerland again. Andrew Wilton called these sketches 'the life-blood of his art', going on to say that:

In them he concentrated everything that he experienced, distilled all that nature could offer the painter. The pages of his Swiss sketchbooks are paintings in plans, studies already more than half transformed into finished works. The book that he used in the Louvre contains plans of other men's pictures, diagrams of their colour scheme, notes on their chiaroscuro, their landscape effects, their emotional force.

A Country Blacksmith Disputing upon the Price of Iron, and the Price Charged to the Butcher for Shoeing his Pony, 1807 (Tate Gallery, London). The first of Turner's interior genre paintings, this was created in response to David Wilkie's *Village Politicians*, which had excited the Academy the previous year.

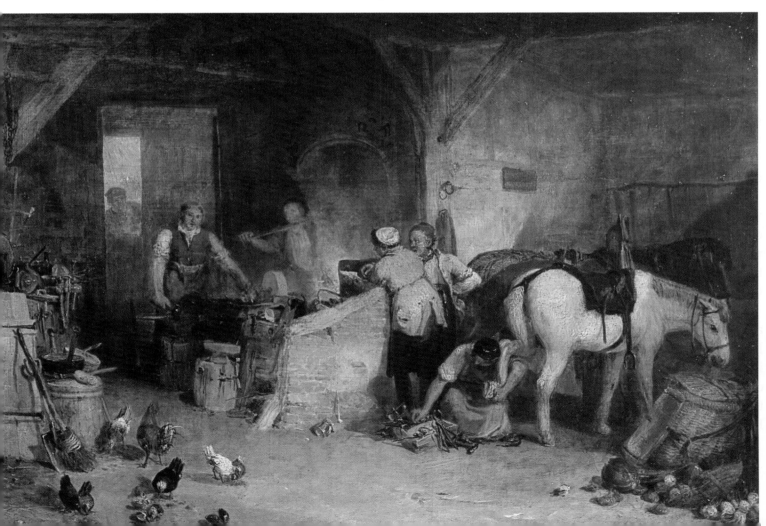

The influence of his travels was more than evident in the work he sent to the Academy in 1803. Two large-scale paintings were exhibited: *Calais Pier* and *The Festival Upon the Opening of the Vintage at Macon*, and both were tributes to the style of one of the old masters. *A Holy Family* was also hung, which was painted following his contemplation of the works of Titian, in particular his *The Death of St Peter Martyr*.

The reviews of Turner's work that year were mixed. Farington quotes the painter John Opie as calling Turner's work 'very fine, perhaps the finest work in the room – that is in which the Artist has obtained most of what he aimed at'. Constable was more damning, saying that 'Turner becomes more and more extravagant and inattentive to nature ... fine subjects but treated in a way that the objects appear as if made of some brittle material.'

The later Swiss paintings did, however, heap almost unanimous acclaim upon the still young painter, and his work was becoming increasingly popular among some of the great English art collectors, including the Earl of Yarborough and Sir John Leicester.

But life in the Academy was not easy during these years. Turner continued to show at his own gallery, and he was achieving some important recognition. He was earning a good living from his painting, but he suffered from a legendary meanness, quibbling about and bargaining for the price of everything. There is a story told that he sold a painting to the Marquis of Stafford for 250 guineas, and then wrote to him several times afterwards in order to have a further 20 guineas paid for the frame.

Turner's father had instilled in him a mercenary approach to money which was compounded by his knowledge that an artist could, at any moment, fall from favour and never earn another farthing. He saved religiously, parting with nothing that was not spent in the name of his art – and even that required haggling.

He fell out with the landscape painter Sir Francis Bourgeois in an extraordinary argument which finished with Bourgeois calling Turner 'a little reptile' and Turner responding with the barb that Bourgeois was a 'great reptile with ill manners' – this among the greatest art establishment of the country. He then fell out with Farington over a minor matter, at which point Farington, in his anger, pointed out that the whole Academy had complained about Turner's conduct and behaviour.

Turner responded by missing several meetings at the Academy, and by moving his home temporarily out of London, to Sion Ferry House, near Isleworth. Turner once again found solace in Thames and its waters and they began to wind their way through his works. His composition became reminiscent of Poussin, and his subject matter took on a new classical impulse. He moved from Isleworth in 1806 to Hammersmith, where he stayed until 1811. He took to painting directly

from nature, in oils, and purchased a small boat on which he sailed up and down the Thames, painting the subtle changes in nature accorded by the seasons, by the light, by the altering tides. He also developed a hobby, which was quite out of character. He became a fervent angler, a skill which he appears to have polished to the same degree as his painting.

It was at Hammersmith that he met Henry Scott Trimmer, who was to become a great friend. Trimmer's son F.E. Trimmer provided Turner's biographers with a wealth of his own memories of the surly painter, for whom he felt a great deal of loyalty and affection. Turner completed a large number of paintings based on the Thames sketches, many of which he imbued with a new classical subject. There was also a rustic feel to much of his work, which was a precursor to Wilkie and to the Victorian fascination with the rustic genre. He exhibited *The Thames near Windsor*, *The Thames at Eton*, *Ploughing up Turnips near Slough*, all based on his original sketches, many of them in oil, painted in open air.

In 1806 David Wilkie, a twenty-one-year-old painter, had exhibited *Village Politicians*, a revolutionary painting which excited the Academy with its political statement. Turner accordingly painted his first interior genre paintings, *A Country Blacksmith Disputing upon the Price of Iron ...* (1807) and *The Unpaid Bill, or the Dentist reproving his son's prodigality* (1808). Andrew Wilton called this immediate response to Wilkie's work: 'Turner's instinct to imitate and improve on the work of his contemporaries, to his sense of the challenge implied by anything that he valued or admired.'

Throughout the first decades of the nineteenth century, Turner was based just outside London, although he continued to live occasionally in the buildings attached to his gallery in Harley Street. His travels were limited by the fact that he was engaged in painting the Thames on his doorstep and required less stimulation, but he did pay visits around the country to friends, and in order to fulfil commissions. He visited Portsmouth in 1807 to see the Danish ships which had been captured at the Battle of Copenhagen and shortly thereafter exhibited *Spithead* at the Academy. Turner received constant commissions from patrons, in particular Sir John Leicester who was so taken with Turner's work that his gallery in London, which was opened in 1819, contained no fewer than eight of Turner's oils, more than any other artist in the collection.

Turner at this time became increasingly interested in engravings made of his work. His rigorous standards meant that he soon found himself as editor and publisher of his prints, and this was extended further when, 1806, William Wells made a plea to Turner, that for his own sake, he 'give a work to the public which will do you justice – if after your death any work injurious to your fame should be executed, it then could be compared with the one you yourself gave to the public.'

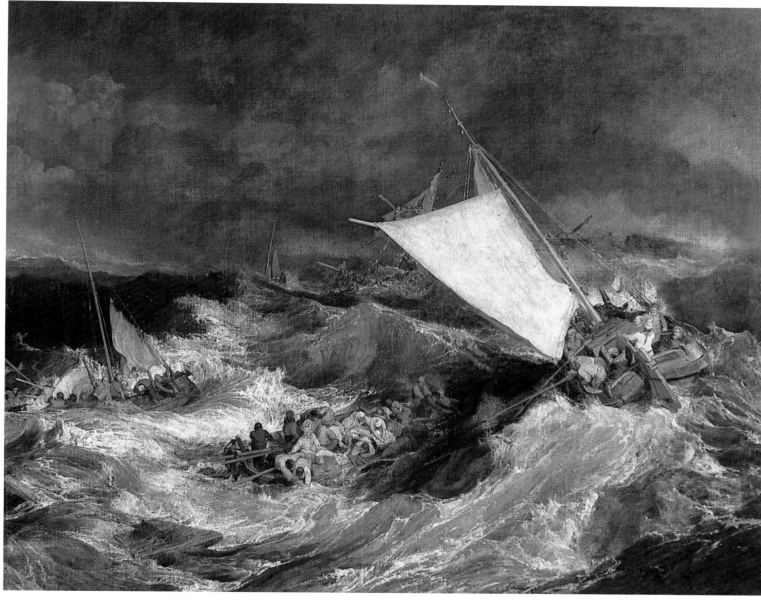

Turner's gallery was firmly established, and he had achieved a position of eminence among his colleagues. He was ready for a new challenge and since engravings were bound to be made of his work, with or without his own involvement, he felt he may as well do it properly, in a manner of which he could be proud. Thus the idea of the *Liber Studiorum* was conceived, based on Claude's *Liber Veritatis*.

The copper-plate engravings, which represented the different categories of landscape and the breadth of his skill in achieving them, were undertaken in mezzotint, which had just been used to engrave *Shipwreck*, an earlier work. *Shipwreck* had been Turner's first oil painting to be engraved and it was a huge success. Fifty prints had been made and sold to an impressive list of patrons and artists, and Turner counted on that support for his new venture.

Shipwreck, *c.* 1805 (Tate Gallery, London). Another painting inspired by the Dutch marine school, this was later engraved in mezzotint – the first of his oils to be represented in that medium.

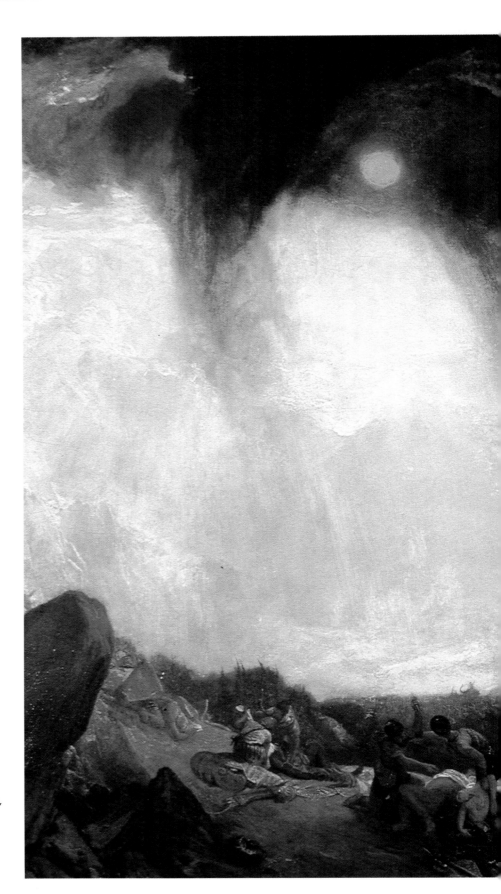

Snowstorm: Hannibal and His Army Crossing the Alps, *c.* **1812** (Tate Gallery, London). Based on Swiss sketches and inspired by his reading of Goldsmith's *Roman History*, this painting was a rich and menacing work, and one which achieved enormous critical acclaim.

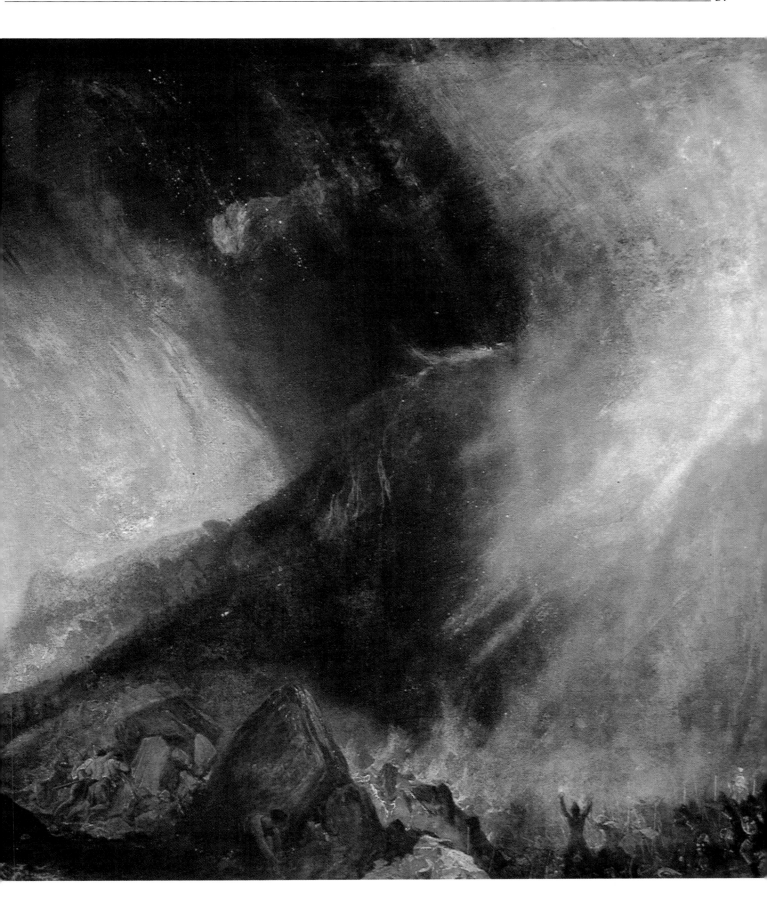

Clara Wells wrote, in 1853:

Turner placed implicit confidence in my father's judgement, but he required much and continued spurring before he could be urged to undertake Liber Studiorum *... my father arranged the subjects, Pastoral, Architectural ... and before he left us the first five subjects which form the first number were completed and arranged for publication.*

He threw himself into the engraving process, undertaking much of it himself at the offices of his various engravers. He rendered each subject in pen and wash, and often prepared the etched outline himself, energetically disapproving proofs as they came off the press. W.G. Rawlinson, who wrote *Turner's Liber Studiorum, a Description and a Catalogue*, described Turner's involvement:

Turner was in the habit of constantly visiting Lahee's printing-office to watch the results of his alterations, and the effects of the new plates. Standing by the press, he would examine each impression as it came off, and with burin or scraper make such changes or retouches on the copper as he thought desirable; sometimes getting his plates into such a muddle that they had to be sent home to him to be seriously treated.

Turner had intended to produce one hundred works for the collection, and did get as far as seventy-one, between the years of 1809 and 1810, before he lost interest in the venture. If the engravings did little for his art, which was most successful certainly for its coloration and evocation of hue and tint rather than its composition, it did a great deal for the engraving industry. Graham Reynolds wrote: '.... by his instruction [he] trained up a school of highly skilled, reproductive craftsmen, much as Rubens had done.'

In 1807 Turner was elected to the position of Professor of Perspective at the Academy, and he set himself to the task with characteristic fervour. He spent years studying and reading and it was not until 1811 that he felt confident enough to make his first lectures on the subject. He prepared dozens of drawings and paintings especially for the exercise, and worked on his presentation, which he knew would let him down. His ideas were sound, his fanatical attention to detail unparalleled, but there still remained the problem of how to get across his vision. His creativity was stifled by his verbal inadequacy. He was equally unable to express his ideology in writing, and this universal theme – frustrated creativity – became the subject of two paintings, *The Garreteer's Petition* and *The Amateur Artist*, both of which were accompanied by Turner's own verse.

Crossing the Brook, 1815 (Tate Gallery, London). This was one of Turner's favourite paintings – one of those chosen to represent his work in a series of five engravings, undertaken late in his career. His daughters were used as models for the figures.

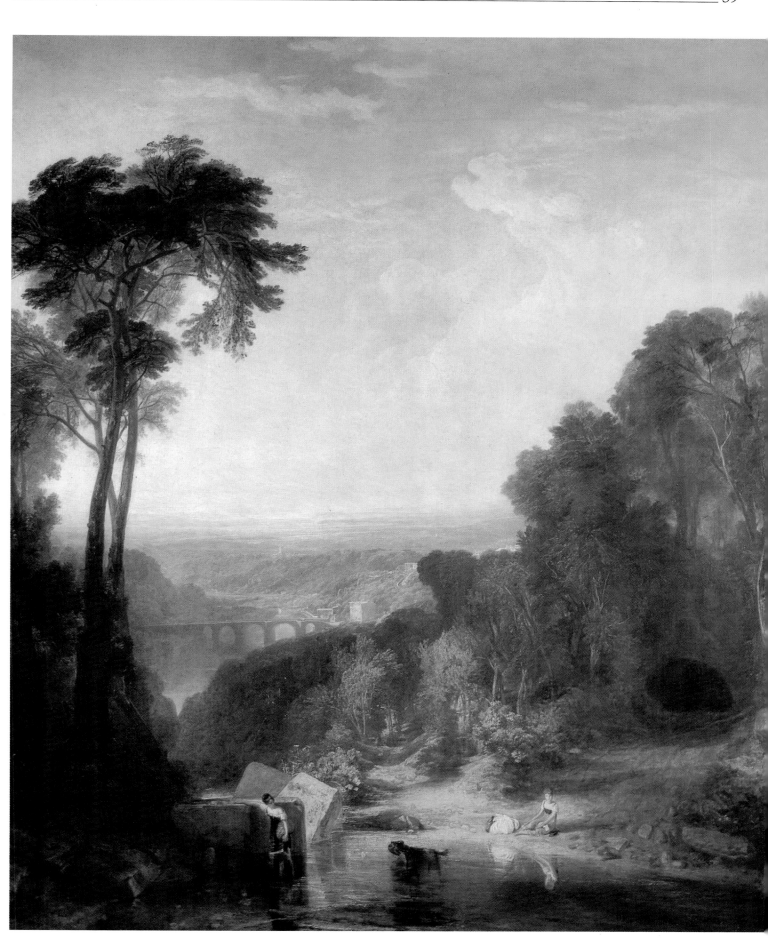

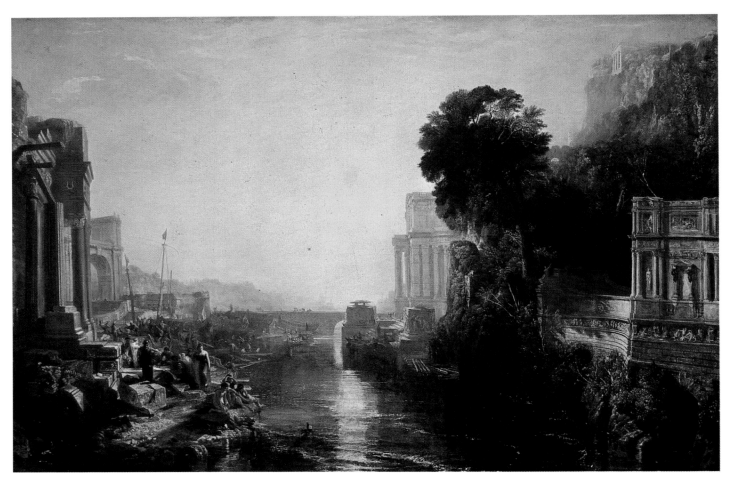

Dido Building Carthage, 1815
(National Gallery, London). Turner
loved this painting so much that he
requested his body be wrapped in the
canvas when he died. The executor of
his will refused to include this clause.

In 1812 he exhibited one of his greatest works, *Snowstorm: Hannibal and His Army Crossing the Alps*, which was a critical success and certainly one of the most majestic of the English landscape paintings. It was based on his Swiss sketches and inspired by his reading of Goldsmith's *Roman History*, in which Goldsmith laid particular emphasis on the terror with which the Alps filled Hannibal and his men. Turner's painting was a dark and menacing work, as rich with the emotion of his subjects as it is rich in the detail of the insuperable beauty of the Alps.

A few years before the exhibition of *Hannibal*, Turner had befriended Walter Ramsden Fawkes, a keen collector of Turner's work and lord of Farnley Hall near Leeds. As he had earlier in his career with William Wells, Turner now made Farnley Hall his second home, revelling in Fawkes's unwavering belief in his genius. He became a country gentleman in the company of Fawkes, fishing and shooting on his estate as if he had been born to the manner himself. Accustomed to being derided for his lowly upbringing, Turner shone in the light of this new attention and the unquestioning acceptance of his suitability for this type of life. The Yorkshire landscape began to emerge in his works, and the frightening atmospheric effects of

Hannibal, in particular, are said to be based upon a storm which Turner had witnessed in the Yorkshire Dales.

In his own mind Turner had become refined, the relationship with Fawkes drawing him away from his customary social ineptness. He had purchased a plot of land at Twickenham and was taking steps to design a small villa, which was built as a retreat and country home for himself and his father, with whom he still had a strong relationship. His mother had died early in the century and his father continued to encourage his son, helping him to prepare his canvases and involving himself in the varnishing process. Turner often joked that his father both started and finished his paintings for him. Turner's relationship with Sarah Danby was, by this time, dwindling, judging by her exclusion from Twickenham. She was kept hidden away from anything to do with his professional life and there is only one mention of her any in of his friends' and colleagues' notes, and that was some time later. He used his daughters occasionally as subjects for his works, including *Frosty Morning* (1813) and *Crossing the Brook* (1815), but little else is known about them.

Sun Rising Through Vapour, 1807 (National Gallery, London). A critic once said that the large majority of Turner's paintings could have been entitled 'Sun Rising Through Vapour'. This particular painting was bequeathed to the nation, to hang between 'two Claudes'.

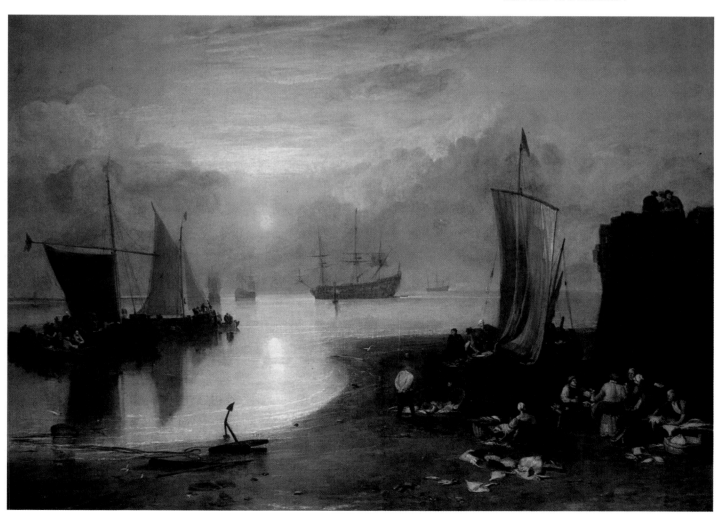

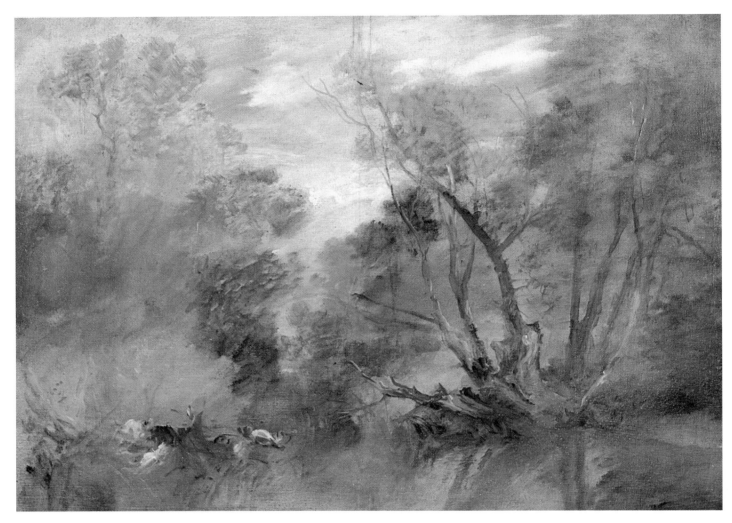

Willows Beside a Stream, 1806-7 (Tate Gallery, London). Turner's landscapes were important in bringing about a greater acceptance of landscape as a genre. Before Turner, anything but idealized landscape was considered art which failed to reflect the human condition.

The perspective lectures had attracted a huge audience, more, it seemed to witness Turner's startling works than to hear his opinions. He attempted to portray himself as a man of great wisdom and intelligence, well-versed and fluent in many of the arts. His great reputation allowed his poor delivery, but as time went by, it became tolerated less until, in 1816, the *New Monthly Magazine* wrote:

> *... excellent as are Mr Turner's lectures, in other respects, there is an embarrassment in his manner, approaching almost to unintelligibility, and a vulgarity of pronunciation astonishing in an artist of his rank and respectability. Mathematics, he perpetually calls 'mithematics', 'spheroids', 'spearides', and 'haiving', 'towaards', and such like examples of vitiated cacophony are perpetually at war with his excellencies. He told the student that a building not a century old was erected by Inigo Jones; talked of 'elliptical circles'; called the semi-elliptical windows of the lecture rooms semi circular, and so forth ... Mr Turner should not ... dabble in criticism; he is too great a master in his own art to require eminence in polite literature.*

However disappointed Turner may have been by criticisms of this ilk, he continued unabashed, and in the same vein. The nature of criticism interested him and he felt, with a forum full of avid listeners, that this was his one chance to make his views heard – as unformulated as they might have been.

He had reached a peak in his work, and in 1815 had published two of his most astonishingly grand paintings: *Crossing the Brook* and *Dido Building Carthage*. The latter painting pleased Turner to such a degree that he requested his body be wrapped in the canvas upon his death. One of the executors of his will, Francis Chantrey, a friend a well-known sculptor, swiftly replied that if such an event were to take place, 'as soon as you are buried I will see you taken up and unrolled' where-upon the will was duly altered and the canvas left instead to the National Gallery.

Eric Shanes describes the significance of *Dido*, which Turner con-sidered the only one of his seaport scenes deserving of comparison to Claude's: 'With its mastery of perspective, its superb exploration of light, shade and reflections, and its total congruence between lighting, pictorial structure and content, it is certainly far more eloquent than Turner's tortuous verbal discourses.'

Turner's travels continued throughout these years, and he visited the West Country, Plymouth (where he undertook another set of open-air oil sketches, for only the second time in his career), and the North of England. Here he travelled for the purpose of collecting sketches for his 'History of Richmondshire' scheme, which was to have 120 water-colours. Like many of his other projects, however, the Richmondshire project petered out when support began to wane. Turner was always filled with great excitement about new ventures, but he regularly over-estimated the public's long-term interest in one project. Throughout his career he consistently involved himself in large-scale endeavours which were left incomplete because either he or his audience had lost enthusiasm.

In 1817, Turner visited the Continent once again, visiting the scene of the recent Battle of Waterloo, which he painted and duly exhibited the following year. *The Field of Waterloo* is influenced by Rembrandt, whom Turner had studied, fresh from a visit to Amsterdam in Holland, and takes up a surprisingly political position against war. The work is superbly lit, like all of Turner's work, and the haunting glow of the corpses is highlighted by the unwavering light of the moon. Turner also travelled through the Rhineland and his friend Walter Fawkes was so impressed that he purchased the complete set of fifty-one water-colours which Turner produced from his sketches.

The friendship between Turner and Fawkes was flourishing, and the older gentleman was increasingly in awe of the painter's talents. He opened his London house to the public, exhibiting his superb

collection of watercolours in which the crowning glory was at least sixty or seventy Turner paintings. In a catalogue which he produced to accompany the exhibition, Fawkes wrote an open letter to Turner, in which he said:

> ... the unbought and spontaneous expression of the public opinion respecting my collection of watercolour drawings, decidedly points out to whom this little catalogue should be inscribed. To you, therefore, I dedicate it, first as an act of duty; and, secondly, as an offering of Friendship; for, be assured, I can never look at it without intensely feeling the delight I have experienced during the greater part of my life, from the exercise of your talent and the pleasure of your society ...

In 1819 Turner visited Italy. He was a solitary traveller, refusing to join other Englishmen, setting up a challenging schedule of painting and studying that took him through most of the country, and he journeyed to Milan, Venice, Rome, Naples, Sorrento and Paestum before visiting Florence in January of 1820. He returned to London with more than two thousand sketches. He worked in watercolour and in pencil and captured brilliant snatches of scenes which would appear throughout his work for the rest of his career. The son of a fellow Academician, Sir John Soane, was travelling in Naples at the time that Turner visited, and Andrew Wilton recounts Soane's impression of the painter at work:

> Turner is in the neighbourhood of Naples making rough pencil sketches to the astonishment of the Fashionables, who wonder of what use these rough draughts can be – simple souls! At Rome a sucking blade of the brush made the request of going out with pig Turner to colour – he grunted for answer that it would take up too much time to colour in the open air – he could make fifteen or sixteen pencil sketches to one coloured, and then grunted his way home.

Turner returned to paint one of his largest and most demanding works: *Rome from the Vatican*. Andrew Wilton comments on its grandeur: 'It is a comprehensive tribute to the eternal city ... In the sweep of its view and the wealth of the ideas that it advances, it is an avowal of what Italy meant to Turner. It demonstrates that he had acquired a new perception in his art ...'

As the decade ended, Turner was established in the villa he had built at Twickenham, now named Sandycombe Lodge. F.E. Trimmer called it 'an unpretending little place'. Turner's father lived there with him as a helper of sorts, working as gardener, cook or artist's assistant

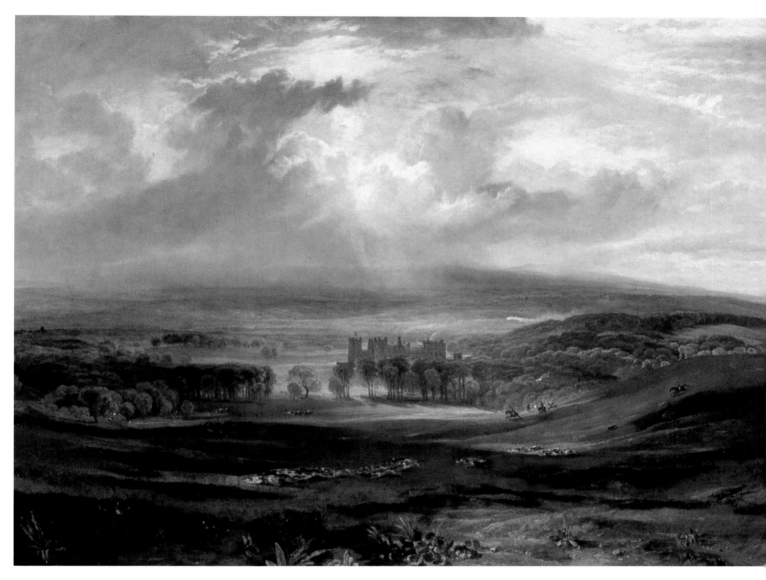

whenever there was call for his services. He also moved back to London with Turner when the pressures of work necessitated his presence. The studio where he worked alongside his gallery at Harley Street had become much too small for Turner's requirements and he began to discuss building a bigger gallery and working area. His canvases of late had become increasingly large and the confined space had become a serious problem. A Queen Anne Street property which adjoined the Harley Street address had been purchased in 1810, and the lease was now due for renewal. It was here that Turner planned to house his new gallery.

Turner's Italian trip had sparked in him an even fiercer dedication to his craft, inspired by the unsurpassed beauty of the Italian landscapes and the exquisite works of the Masters. The expansion of his gallery and his home was reflected in the expansion of his ideology, which heralded the next great phase of Turner's life and work.

Raby Castle, 1818 (Walters Art Gallery, Baltimore). Commissioned by the third Earl of Darlington, this was sketched and then painted following Turner's trip to the battlefield of Waterloo, and his journey up the Rhine. The Continental influence is evident.

CHAPTER 3

Complicated Affairs (1821-1840)

Introduced to-day to the man who beyond doubt is the greatest of the age; greatest in every faculty of the imagination, in every branch of scenic knowledge; at once *the* painter and poet of the day, J.M.W. Turner.

John Ruskin, 1840

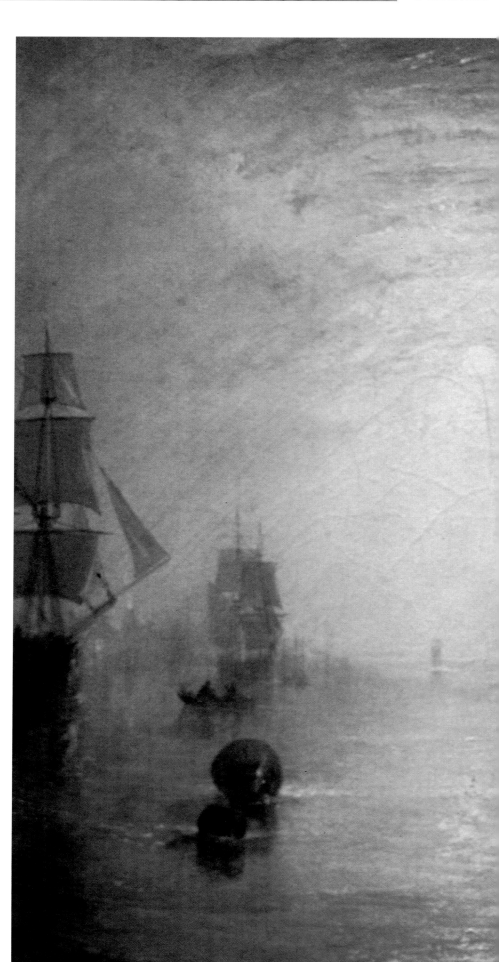

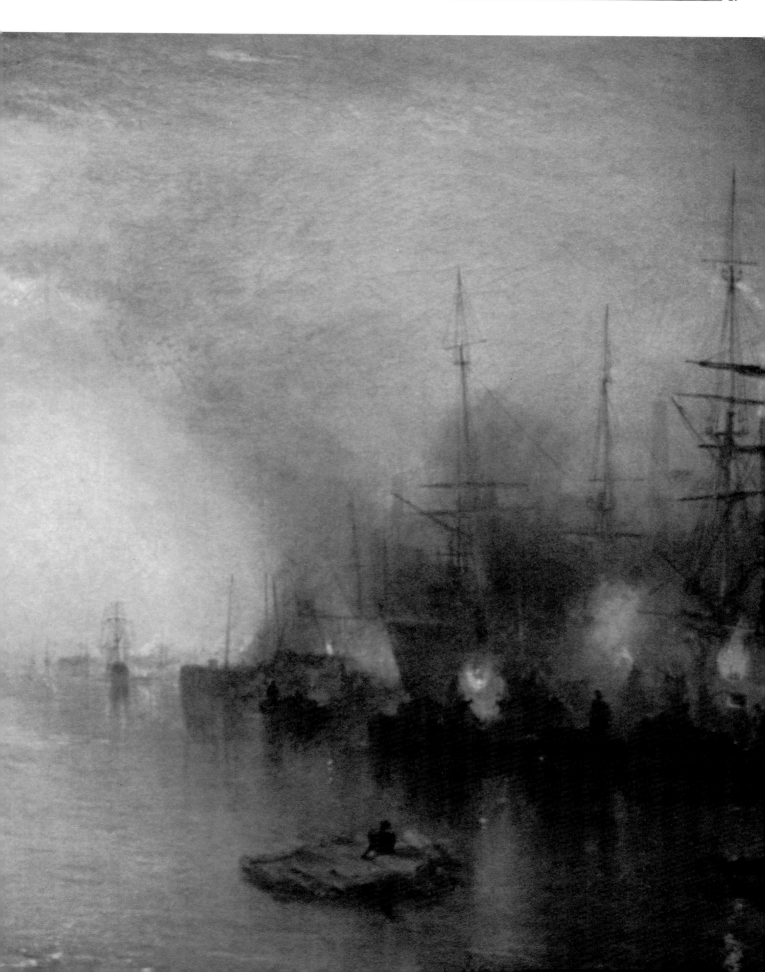

The years after Turner's first trip to Italy were marked by a less prolific output and a new, significant series of paintings worked in tribute to the great works of others. Turner continued his travels, but his life grew more complicated, and he was beset by a series of bereavements which left him lonely and uprooted. It was at this phase of his life that he shrugged aside the feelings of inadequacy which had haunted him for so long, in order to concentrate on the pleasures of life. He began to be much more sociable, attending parties, befriending a number of fellow artists and entertaining them in the comfort of his country home in Twickenham. His style changed a great deal throughout this period, some of it wildly applauded, and some of it derided by all. Turner was unperturbed by the attentions. He was professionally secure, and he set about his work with an enlightened calm.

Sarah Danby had ceased to be a regular part of his life and there is little mention of her, other than a desultory £10 annuity left to her in the first will Turner had drawn up. Her niece, Hannah, had become his housekeeper and she featured more in his day-to-day life. There is a school of thought which believes that Hannah was the mother of his two children, and not Sarah, as was originally thought – a premise that could be borne out by the fact that Hannah was rewarded by a sizeable legacy when Turner did die. But judging by Turner's previous control over his financial affairs, it would not be surprising if the mother of his children received nothing.

Turner had inherited some property from a long-lost uncle, in Shadwell, near the Thames, and he turned two buildings into a public house, which he visited from time to time in order to collect rent. He now owned a number of properties in and around London and his affairs had become much more complicated. But he seemed to thrive on this patent acknowledgement of his success. His home at Twickenham became a meeting place for friends and colleagues, including Francis Chantrey. A new friendship blossomed in the form of the painter David Wilkie, who wrote, following a dinner in 1821, that 'Turner was a distinguished guest ... we found him a good-humoured fellow, neither slack in wit himself, nor loth to be the cause of wit in others.' He had become closer to his father, too, and they had a comfortable relationship in which they bickered constantly, and in which each blamed the other for the lateness of dinner, and other domestic matters.

Turner's painting at this time reflected the ideology he had adopted after Italy. He experimented with colour, and worked more in oils, finding a new richness which he was able to render with the fluidity and evocation of light that he had mastered so thoroughly in the medium of watercolour. He was popular with the old school of the Academy and a whole new generation of young artists now offered him their whole-hearted support. He was the doyen of the Academy, a

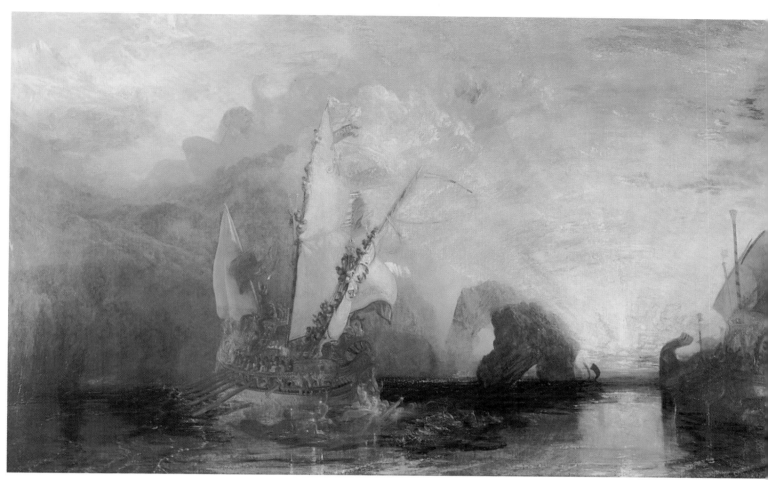

Ulysses Deriding Polyphemus, 1829
(Tate Gallery, London). Painted with a richer, more seasoned palette, this work is, like many of his paintings, based around a classical theme. Turner was embarrassed by his lack of cultural refinement and spent much of his life studying literature, which he used increasingly as the subjects for his paintings.

position for which he had fought long and hard. His experiments with colour had broken new ground; his theory had been inspired by his studies of the science of optics, which he had undertaken for his lectures on perspective, and by 1823, an encyclopaedia published in 1823 said that Turner's genius 'seems to tremble on the verge of some new discovery in colour'. That discovery was seasoned by the end of the 1820s, evident in the form of *Ulysses Deriding Polyphemus*, which relied much more heavily on primary colours to achieve its luminous effects.

The new gallery, in London's Queen Anne Street, was opened in 1822, and most of the work which Turner did complete was hung here, alongside some of the best of his old works. He had become increasingly unable to part with his paintings and sketches. Andrew Wilton writes:

> *He had made a deliberate decision, it seems, to concentrate on practicalities ... his vacillation, his alternating wish to sell his work and to retain it, his conflicting instincts to disseminate his ideas by every available means of publicity, and to hoard and save them until they could be presented in toto to the nation, all reveals not doubt but a profound inner conviction that his work was of supreme importance.*

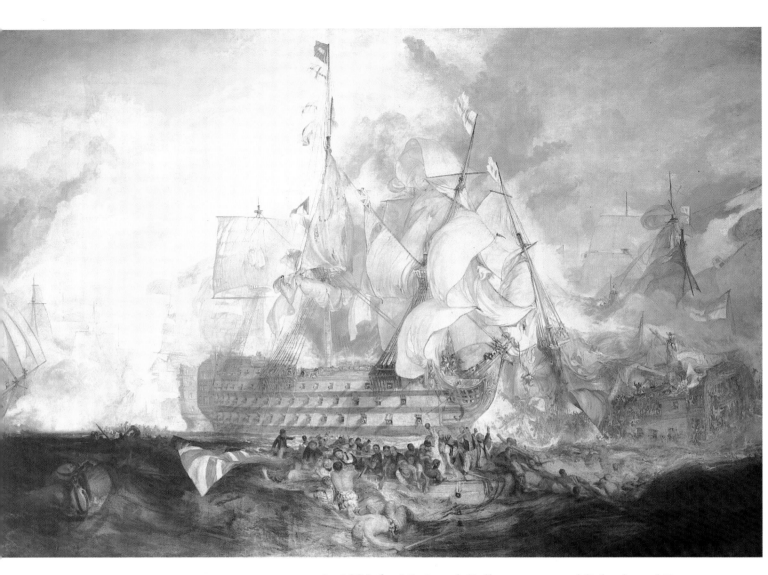

Battle of Trafalgar, 1806-8 (Greenwich Naval Hospital Collection). This painting, commissioned by King George IV, was considered historically inaccurate and relegated to the Greenwich Naval Hospital instead of being hung at the Palace.

In 1824 the National Gallery was established, and Turner was on the committee to decide where to house it. It was perhaps this impetus which stirred in Turner the idea for a complete collection of his own work, housed one day in such an establishment, which convinced him in the end to hold on to most of it.

Another ambitious project was undertaken at this time, in the form of a plan to produce a series of works based on the progress of George IV on his visit to Scotland in 1822. The novelist Sir Walter Scott had planned the pageant for the occasion and Turner set out his proposal for twenty paintings, all of which would be engraved. Only two or three sketches resulted from this grand scheme, which was characteristic of Turner's exuberant but short-lived enthusiasm for his projects, which became increasingly ambitious as he grew older.

A commission from the King himself was Turner's next project, and it is likely this which encouraged him to drop the idea of the Scotland series. He was to paint the Battle of Trafalgar for the King's

Levée Room. Turner spent months working on the painting, altering the rigging of the ships according to the views of the various naval representatives of the King, and then changing them again when someone else voiced a different view. He struggled for historical accuracy, but it was due to its inaccuracy that the painting was eventually rejected by the Court. It was not hung, as planned, in the house of Hanover, but was sent off to the Royal Naval Hospital in Greenwich, where it remains today. Turner had never been an accurate historian; he had always successfully engaged the very best of many events to create a representation of an occasion rather than a painting that was strictly correct. This philosophy did not appeal to the King, who wanted documentation, not fancy.

Turner was wounded by the slight, and later, when David Wilkie was knighted by William IV and his own protégé, the painter Augustus Wall Callcott, was similarly honoured by Queen Victoria, he began to feel persecuted. But Turner had ingratiated himself with a number of artists and artisans who had found favour with the court, in particular the architect John Nash, with whom Turner stayed at East Cowes Castle on the Isle of Wight in 1827. Turner stayed long enough to fill four sketchbooks, and from them were painted works like *East Cowes Castle, the Seat of J. Nash, Esq., the Regatta Beating to Windward*, and *East Cowes Castle, the Regatta Starting for Their Moorings*, both of which were exhibited at the Academy in 1828.

It has been suggested that Turner had become comfortable with the elegant surroundings of Cowes Castle, with its congenial company, and it was this which inspired his *Boccaccio Relating the Tale of the Birdcage* which was also exhibited in 1828. This work was considered a tribute to Thomas Stothard, whose illustrations accompanying the *Decameron* had recently been published. There is, in fact, no story of a birdcage in the *Decameron*, and it is likely that Turner's title represented a joke among his colleagues.

The years up to his time at Cowes Castle had not been easy ones. The commercial crash of 1825-6 had cost many of Turner's friends a great deal of money, in particular the Fawkes family, to whom he was close enough to actually break with tradition and lend money. The sudden death of his friend Walter in October 1825 deeply affected Turner and he refused to visit Farnley Hall again. Turner had also received some bad reviews for some of his works, exhibited in 1826, in which his new prolific use of yellow was lambasted by the critics. The *British Press* of 30 April wrote:

> *Mr Turner has degenerated into such a detestable manner that we cannot view his works without pain. He is old enough to remember de Loutherbourg, whose red-hot burning skies were as repulsive as these saffron hues of his own. We mention this not unkindly, and*

**East Cowes Castle, The Regatta
Starting for Their Moorings, 1828**
(Indianapolis Art Museum). Turner
stayed with the architect John Nash at
East Cowes Castle, when he visited the
Isle of Wight. This painting was based
on sketches made during his stay in
1827, and hung at the Academy in 1828.

wish Mr Turner to turn back to Nature and worship her as the goddess of his idolatry, instead of his 'yellow bronze' which haunts him.

The paintings in question were *Forum Romanum, for Mr Soane's Museum* and *Cologne, the Arrival of the Packet Boat*, both inspired by Turner's European trip. He was comfortable with the progress of his art. He had the respect of many of his colleagues, and a new and easier relationship with many of his fellow Academicians. He had found a group of like-minded painters at the Academy and the titles of their works developed into a series of running jokes, beginning with Callcott's *Dutch Fishing-Boats Running Foul, in the Endeavour to Board, and Missing the Painter-Rope*, to which Turner responded by exhibiting in 1827, *Now for the Painter (Rope) Passengers Going on Board*. Turner was altogether more confident and relaxed about his position in the art world.

He had begun, in 1825, another series of watercolours which he planned to engrave, despite the notoriously incomplete earlier projects. The series was entitled 'Picturesque Views in England and Wales'. The original proposal was for 120 watercolours, but the decreasing interest of the public led to its being finished at only 100. In 1829 and 1833, he exhibited 'England and Wales', which comprised almost seventy watercolours made for the series, in which the scenery captured by Turner throughout his extensive travels in his own country was celebrated. The collection was stunning, illustrating the breadth of Turner's skills, and his extraordinary use of colour. The series itself was deemed to be the central 'document of his art'. He went on to work on series of ports and rivers in England, and then moved to book illustration. He was a tireless worker, and his paintings were in huge demand. He provided illustrations for the prose works of Sir Walter Scott, and some landscapes for an illustrated edition of the Bible. He was also commissioned to illustrate the poetry collections of Byron and Scott, among others – an undertaking which filled him with glee, as it provided him with the opportunity to venerate the strong relationship between verse and art which he had always felt existed.

In 1829, Turner returned again to Rome, travelling to Italy through the South of France. This time his trip was not so heavily scheduled and he enjoyed the company of some of the Englishmen abroad, cutting a fine figure and holding his own in conversation and in the social events of the English expatriates there. He held a one-man show while he was in 'Rome, framing his works with lengths of rope which he painted with yellow ochre. It was reported that more than a thousand visitors went to see the exhibition, which comprised paintings like *View of Orvieto...* and *Regulus*, which laid new ground in their use of colour and in their technique. On his return from Italy, his carriage was turned over in the snow, and his painting *Messieurs Les Voyageurs*

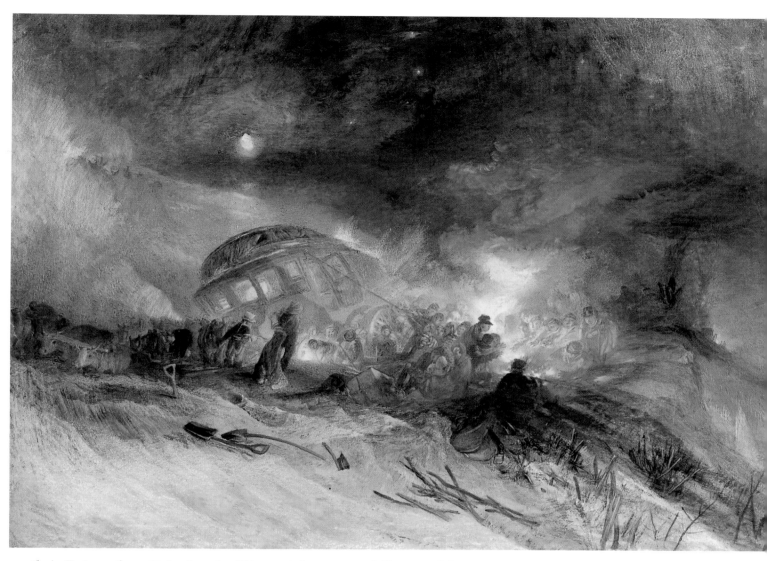

on their Return from Italy (par la diligence) in a snow drift upon Mount Tarrar, 22nd January 1829 was the result.

In 1829, Turner also painted *Ulysses Deriding Polyphemus*, which is one of the greatest works in his entire *oeuvre*. The composition is based around a drawing he had created nearly two decades earlier, a classical subject which Poussin had also addressed. Graham Reynolds notes:

> *The staggering richness of colour shows that he has absorbed the lessons and reflections of his second visit to Rome. The decorative and baroque poop upon which Ulysses is sailing resembles the vessel on which Etty had shown Cleopatra's arrival in Cilicia in 1821; the nymphs which attend it are an especially happy example of Turner's imagination playing on the classical story.*

Reynolds also pointed out that Turner's experience of painting in the Roman light was a 'further step in his increasing liberation from a

Messieurs Les Voyageurs on their Return from Italy ... , 1829 (British Museum, London). Turner's carriage overturned in the snow on his return from Italy, through the South of France, in 1829. He painted this fiery and rather fantastic painting upon his return. The painter can be seen at the centre of the fire, his back to the viewer, his customary top hat in evidence.

Music Party, East Cowes Castle, *c.* **1835** (Tate Gallery, London). Turner completed hundreds of sketches during his visits to the Isle of Wight. Many works were based around the boating events, but Turner was beginning to pay more attention to interiors and social gatherings.

tonal palette towards the freedom of colour in his later works'. That new use of colour was manifested in *Ulysses* which was received with mixed reviews. *The Morning Herald* wrote:

> *This is a picture in which truth, nature and feeling are sacrificed to melodramatic effect ... he has for some time been getting worse and worse and in this picture he has reached for the perfection of unnatural tawdriness. In fact, it may be taken as a specimen of colouring run mad – positive vermilion – positive indigo; and all the most glaring tints of green, yellow and purple contend for mastery ...*

But it was these very colours which pulled Turner's work beyond a stagnating pastel mediocrity. His liberation of light was as profound as ever, explored ever more deeply in the colours which his Roman trip had inspired him to use.

Turner had intended to return to Rome again that year, but his father, at eighty-five, was not well, and Turner remained behind to care for him. William Turner died in September 1829, and Turner was shattered by the loss of his best friend and companion. He buried his father in St Paul's Church, Covent Garden, and composed the epitaph himself, which read:

> IN THE VAULT
> BENEATH AND NEAR THIS PLACE.
> ARE DEPOSITED THE REMAINS OF
> WILLIAM TURNER
> MANY YEARS AN INHABITANT
> OF THIS PARISH, WHO DIED
> SEPTEMBER 21ST 1830
> TO HIS MEMORY AND OF HIS WIFE
> MARY ANN
> THEIR SON J.M.W. TURNER R.A.
> HAS PLACED THIS TABLET
> AUGUST 1831

Turner's clumsy turn of phrase has been attacked, but his intentions are sweetly recorded. Sadly, the artist had not remembered the correct year of his father's death.

There was a story told of the erection of the tablet which illustrates Turner's legendary meanness. Some masonry work was still to be undertaken and the sum of seven odd shillings was owed to the mason, which was duly paid by Mr Cribb, the churchwarden who expected to collect it from Turner at a later date. When he mentioned the money to Turner, he was told to return later with a receipt, at which point he would be paid. A receipt had not been requested, and Turner made no move to pay the Mr Cribb, which is as astonishing today as it must have been then.

But Turner was not entirely mean spirited. When his father died he was moved to address his own mortality, and he immediately made a will in which the bulk of his money would go to the construction of a group of almshouses, which would be built on some land Turner had set aside in Twickenham. He envisioned a kind of poorhouse for 'decayed English artists (Landscape Painters only) and single men'. The buildings would also house a collection of his own paintings.

Turner was still intent on having his works presented at some date in their entirety and whenever one of his important canvases came up

for auction he set about buying it back. He purchased back *Sun Rising Through Vapour* and *A Blacksmith Disputing the Price of Iron ...* in this manner.

Turner spent more and more time away from London as memories of his father haunted him in their shared homes. His new friend and patron Lord Egremont opened his home at Petworth to the artist and much time was spent here, in similar circumstances to the arrangement he had once had with Walter Fawkes. William Wells also died around this time, as did his daughter, Clara's sister. Turner was surrounded by bereavement, all of which affected him intimately. His family 'broken up', as he said, Turner returned again to the Continent in 1833, where he travelled to Venice and Vienna, taking in East Germany and Denmark en route, and, in 1836, back to his fair Switzerland, the source of some of his greatest inspiration.

From the 1830s he had developed a new interest in the human figure, evident in his paintings *Jessica* and *Lady Trying on a Glove*, and he continued to experiment with the portrayal of light through colour. Graham Reynolds describes Turner's growing formlessness, which he attributes to the emphasis on tonal accuracy:

> *While Turner had retained a miraculous tact in the management of light throughout his pictures, the result of his reflections, his experience and his Italian journeys was to direct his interest towards the colour in the visible world, if need be at the expense of its form. His always present fascination for the immaterial vehicles of colour, steam, smoke, mist, helped him to make this choice. So in the later finished pictures he composes in colour, dissolving, suggesting, and only half-defining form; in his private exercise he composed in coloured washes alone, virtually excluding any reference to the forms of nature ...*

His travels offered new opportunities for settings and atmospheric effects, and he was open to the influence of the Continental painters, including the Nazarenes, whose use of colour enthralled Turner, and the painters of the Quattrocento, whose frescoes provoked a similar appraisal. In the spring of 1833, Turner showed *Bridge of Sighs, Ducal Palace and Custom-House, Venice: Canaletti Painting at the Academy*, a reference to the Italian Canaletto, whose style and composition he had borrowed for this work.

Turner continued to show both at his own gallery and at the Academy, but the years had mellowed Turner and although his professional jealousies demanded that he fix and then maintain his position within the hallowed walls of the Academy, he undertook this task with a touch of mirth. In particular, his behaviour at the varnishing days of the Academy in the early 1830s have become legend. Varnishing days

were set up from 1809, in order that artists could have three or four days in which to retouch or alter work, which was sometimes necessary because of the situation in which they were hung. Turner's submissions were almost always bland, weak drawings which made little impact upon their neighbours when originally hung. That is, of course, until varnishing days came round.

Turner arrived with paints under arm and addressed these canvases, some of which had just the backgrounds laid in. G.D. Leslie, in the *Inner Life of the Royal Academy*, wrote:

> *Turner went about from one to another of them on the varnishing days, piling on, mostly with the knife, all the brightest pigments he could lay his hands on, chromes, emerald green, vermilion, etc., until they literally blazed with light and colour. They looked more like some of the transformation scenes at the pantomime than anything*

Juliet and Her Nurse, 1836 (Private Collection). This painting astounded critics. How, they asked, could Juliet be looking over the city of Venice? Turner had seen *Romeo and Juliet* while in Venice and he transposed that memory on sketches made in 1833.

else. Artists used to dread having their pictures hung next to his, saying that it was as bad as being hung beside an open window ... Turner used to send these pictures into the Academy with only a delicate effect, almost in monochrome, laid on the canvas, and very beautiful they looked, often like milky ghosts ... all the bright colour was loaded on afterwards, the pictures gradually growing stronger in effect and colour during the three varnishing days ...

Constable was one artist who had had the misfortune to have his work hung next to Turner's. C.R. Leslie, in *Autobiographical Recollections*, relates a story that has made art history:

In 1832, when Constable exhibited his Opening of Waterloo Bridge, *it was placed in the school of painting ... A sea-piece, by Turner was next to it – a grey picture, beautiful and true, but with no positive colour in any part of it. Constable's* Waterloo *seemed as*

Pilate Washing His Hands, *c.* **1830** (Tate Gallery, London). Inspired by Turner's Roman trip the previous year, this oil painting was exhibited at the Academy in 1830. Its composition and deep palette are reminiscent of the Italian Masters.

Petworth, Sunset on the Park, 1828
(Tate Gallery, London). Turner befriended his patron Lord Egremont, and Petworth became his second home. When Egremont died in 1837, Turner never visited his home again.

if appointed with liquid gold and silver, and Turner came several times into the room while he was heightening with vermilion and lake the decorations and flags of the city barges. Turner stood behind him, looking from the Waterloo *to his own picture and at last brought his palette from the great room where he was touching another picture and putting a round daub of red lead, somewhat bigger than a shilling, on his grey sea, went away without saying a word. The intensity of the red lead, made more vivid by the coolness of his picture, caused even the vermilion and lake of Constable to look weak. ... 'He has been here,' said Constable, 'and fired a gun.' ... The great man did not come again into the room for a day and a half; and then in the last moments that were allowed for painting, he glazed the scarlet seal he had put on his picture, and shaped it into a buoy.*

An Artist Painting in a Room with a Large Fan Light, *c.* **1828** (Tate Gallery, London). Turner often lit his paintings from behind, providing them with a central source of illumination. This allowed him to concentrate on the overall impression rather than the detail of the foreground.

Stories of Turner's competitive instinct abound, but one cannot help but admire his confidence in his own ability to work quickly, and at the last minute produce a work which was better than all those of his contemporaries. They were a close-knit group of artists on those varnishing days, one of the few times when all Academicians were together, able to trade stories and discuss changing styles. Turner's style was ever changing – one minute adopting the bright colours inspired by his Italian travels, another the deepened palette of the Dutch-inspired marine paintings, like *Helvoetsluys*.

Juliet and Her Nurse was painted in Venice, its Shakespearean subject endowed with a new Venetian setting. Turner had, in fact, seen a performance of *Romeo and Juliet* while in Venice in 1833 and had superimposed the sketches he made on to the larger-scale landscape study, but critics were confused by the painting, and wondered at what they considered his poor education or, perhaps, a joke that they were

missing. It was by now a Turner trademark that he applied scenes to whatever bits of landscape seemed to fit, so it is incomprehensible that *Juliet and Her Nurse* should have caused such a stir. Turner was interested in drama and in literature, and many more of his works were undertaken around this theme.

Juliet and Her Nurse was shown in 1836 with two other canvases. *Blackwood's Magazine* published a scathing report on Turner's submissions, in particular *Juliet*, noting:

> *... This is indeed a strange jumble ... It is neither sunlight, moonlight, nor starlight, nor firelight, though there is an attempt at a display of fireworks in one corner ... the scene is as a composition as from models of different parts of Venice, thrown higgledy-piggledy together, streaked blue and pink, and thrown into a flour tub*

Turner was unmoved by the attack, a seasoned exhibitor now used to such vitriolic addresses. Another young man was, however, enraged to such an extent that he dedicated himself to the idea of vindicating Turner, whom he considered an artist with a status

Venice, the Piazzetta with the Ceremony of the Doge, *c.* **1835** (Tate Gallery, London). Turner was inspired by Venice, with is shimmering waterways and stunning architecture. This painting is more impressionistic than some of his earlier work, but the bold expanses of colour add definition.

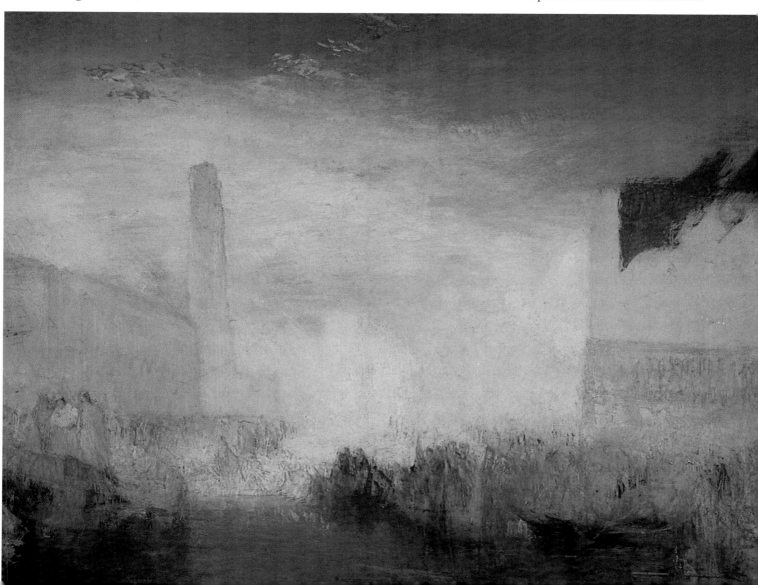

somewhere near to God's. This young man was John Ruskin, an extraordinary seventeen-year-old who would, one day, change the face of art in England. Ruskin wrote prose descriptions for Turner's works and sent them to Turner for approval, with the idea of having them published. Turner humoured the irate young man, but kept the manuscript for the picture's owner. It was the basis of a strange but significant relationship.

The 1830s were years of personal growth for Turner. His friendship with Lord Egremont flourished, and he became a member of the family, who treated him as if he truly belonged. The atmosphere of the household set him at ease, and he was remembered as being a jolly companion, attentive and very caring. Andrew Wilton writes:

> *Egremont managed to combine aristocratic aloofness with geniality and an obsessive desire for companionship: Turner found the conditions ideal. He was free to amuse himself as he liked in a beautiful setting, to talk with his host or with the many colleagues from the Academy who were fellow-guests, to paint or draw either in the Old Library where he had a studio, or anywhere in the house and park: several of the colour studies show bedrooms, while many record evening gatherings, conversations, discussions between artists ...*

Turner was dealt another blow when Egremont died in November of 1837. As he had done with his dear friend Fawkes, he refused to return to Egremont's home. A prickly character, Turner was not easy to get to know and it took him some time to warm to others. Time and again he would make a deep and lasting friendship, only to have it torn apart by a tragic death. His life was filled with sorrows, his growing comfort in the company of others shattered just as he was beginning to learn to trust. As a child, his mother's madness had meant that for him she was effectively dead; although a shell of what she had once been existed, there was an unpredictable insanity raging inside. His sister, his father, his dearest friends had all passed on. Turner was successful; indeed, he must have been quite rich. But his private life was lonely, women taken on for companionship here and there; nothing lasting existed.

There is some evidence that after the relationship with Sarah Danby had ended, Turner found sexual release with prostitutes near the pub he owned in Shadwell. Indeed, there were sketches made of 'sailor's women', and later, a sketchbook in which he depicted couples in bed together. This sketchbook was referred to by Ruskin as 'evidence of the failure of mind only', which is amusing in light of the fact that Ruskin was renowned for the public announcement of his own impotence, following the annulment of his unconsummated marriage to his wife Euphemia.

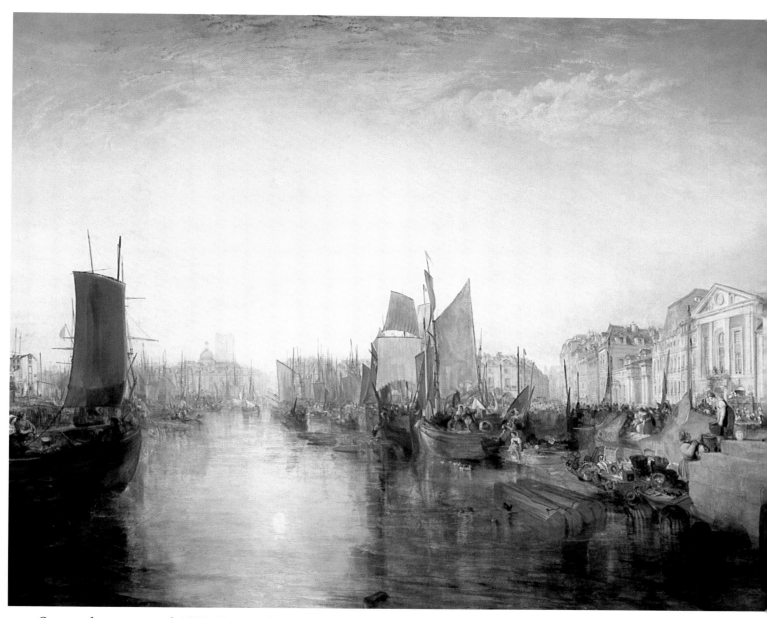

Somewhere around 1833, Turner became involved with another woman, Sophia Caroline Booth of Margate, twice widowed and entirely self-sufficient. Sophia Booth was the landlady of the lodgings where Turner stayed on his visits to Margate, a childhood haunt which he still loved to paint, and she was to become a comfortable fixture in his personal life until his death.

The last decades had been years of extraordinary creative energy and output for Turner. He had settled into a routine of personal challenges which consistently improved his art, which made his name legend, and which accorded him the respect that was undoubtedly his. The last ten years of his life would see the ripening of his vision, which would place him firmly in the annals of art history as the greatest English colourist and perhaps greatest landscape artist of all time.

The Harbour of Dieppe, *c.* **1826** (Frick Collection, New York). This painting, hung at the Academy in 1826, was considered by many critics to be 'grand but unnatural' in colouring. Again, the central focus is the light and its reflection on the waters of the port.

CHAPTER 4

A Mature Vision (1841-1851)

Two more deaths at the beginning of the 1840s drew Turner deeper into himself, where he fostered an isolation that became the source of much bewilderment among his colleagues.

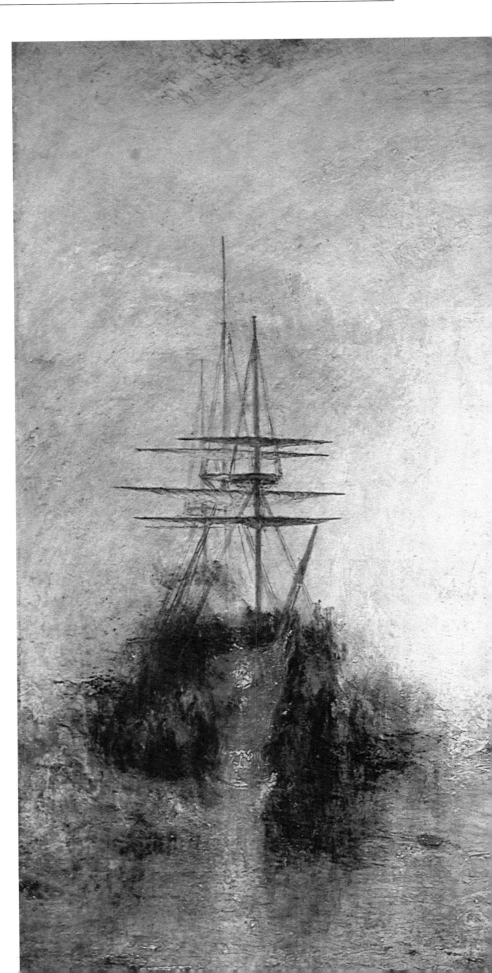

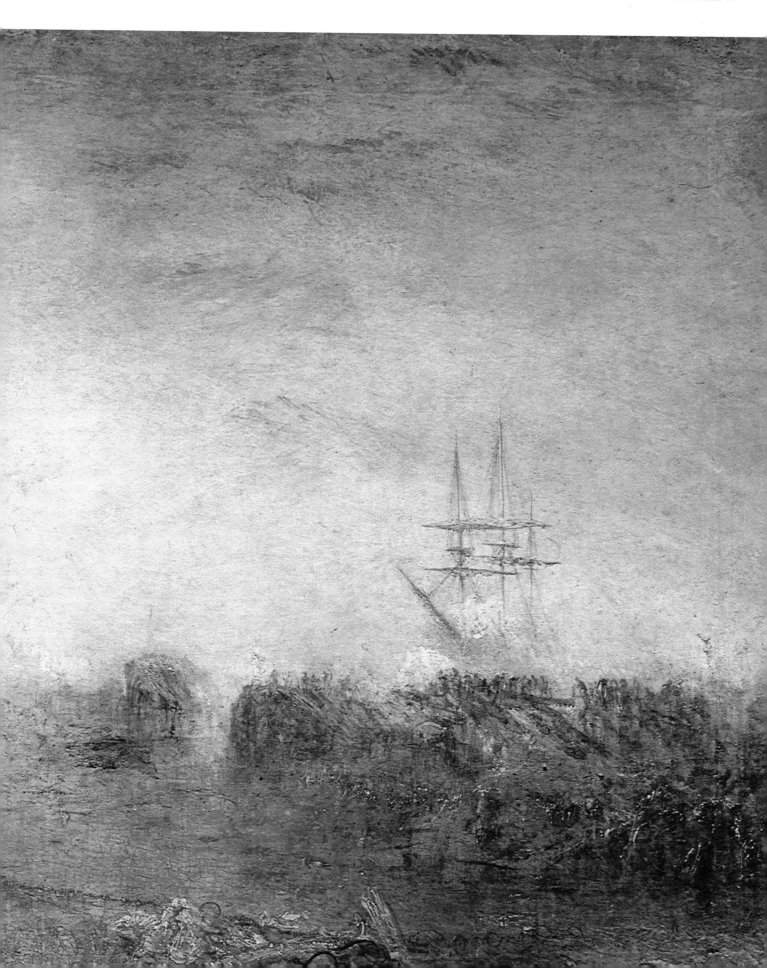

Overleaf:
Whalers (Boiling Blubber) Entangled in Flaw Ice ... *c.* **1846** (Tate Gallery, London). Turner painted a series of whaling pictures, based around the superb collection of the whaler Elhanan Bicknell, and calling upon Thomas Beale's *The Natural History of the Sperm Whale,* to which he makes references in the catalogue accompanying the works.

The death of David Wilkie, fellow Academician and close friend, in 1841 caused Turner enormous grief. Only months later Francis Chantrey died, and Turner lost the last of his real friends. The house at Queen Anne Street sank into a state of disrepair, still attracting hoards of art lovers, anxious to make an appointment to see the studio of the great landscape master, and to view his works, but never again would it be the busy place that it had been in Turner's heyday. Turner had never encouraged his colleagues to become too friendly; he kept his personal life completely secret. Very few of his friends had even seen inside the Queen Anne House, other than the areas set aside for viewing. Now they were not even encouraged to do that. Any entertaining had been undertaken at Twickenham, but following the death of his father, that too petered out, and the private life of J.M.W. Turner became the object of much speculation.

In 1846 he moved with Sophia Booth to a secret cottage on the banks of the Thames in Chelsea, and there is some evidence that he adopted the identity of Admiral Booth, to confound the attempts of his friends to find him.

Sophia was described as being overweight and quite unattractive. Following Turner's death, Charles Turner described her as 'exactly like a fat cook and not a well-educated woman'. She was in her thirties when her husband died and she was simple and industrious, an ideal companion for Turner, who had become weary after his years of indefatigable work. She had also been left with money of her own, and required nothing from Turner, which, in light of his miserly nature, was just as well. David Roberts, one of Turner's fellow painters, talked to Sophia immediately after his death, and discovered some fascinating information:

> ... for about eighteen years ... they lived together as husband and wife under the name of Mr and Mrs Booth ... But the most extraordinary part of her naritive [sic] is that, with the exception of the first year, he never contributed one Shilling towards their mutual support!!! – But for eighteen years she provided solely for their maintenance and living but purchased the cottage from money she had previously saved or inherited ... Turner refusing to give a farthing towards it ... She assures me that the only money She has belonging to him during this long term of years was three half crowns She found in his pocket after death, black, She says, with being so long in his pocket ...

Turner continued to patronize the Academy on a regular basis, and to spend evenings out with Associates and fellow artists, but he returned in secrecy to his cottage, where Sophia and her son (some

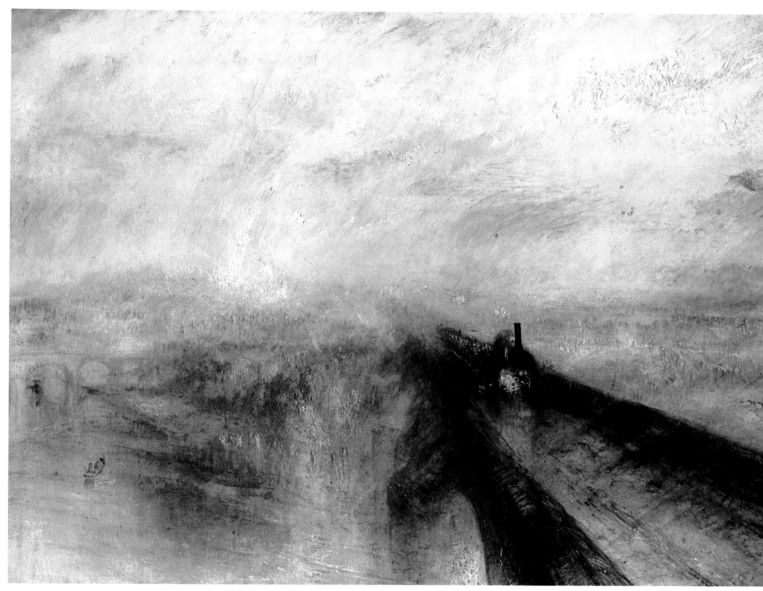

Turner was the father), Daniel John, awaited him. John Burnet, in *Turner and His Works* (1852) wrote:

Now and then as an after dinner freak, men who were intimate with Turner, as intimate, indeed, as any men could well be with one of his close and eccentric habits, endeavoured to discover his new abode by many odd devices ... But he was not to be trapped. Offers were made to walk home with him from the Athenaeum – for a little chat about Academy matter, such as the new Associate and the election of a President. No; he had got an engagement, and must keep it. Some of the younger sort attempted to follow him, but he managed either to get away from them or to weary them with the distance and his dartings into cheap omnibuses or round dark corners ... He was not, however, to be caught.

Rain, Steam and Speed – The Great Western Railway, 1844 (National Gallery, London). Turner considered this painting to be one of the greatest of his modern themes, in which realism plays a more important role. Ruskin dismissed it, saying that it only proved 'what he could do even with an ugly subject'.

Light and Colour (Goethe's Theory) – The Morning After the Deluge – Moses Writing the Book of Genesis, *c.* **1843** (Tate Gallery, London). Turner painted this after reading Goethe's *Theory of Colours*. The painting serves to celebrate Turner's own theory of colour, which he called, 'The ancient simbolical [sic] notion of colour to designate Qualities of things'.

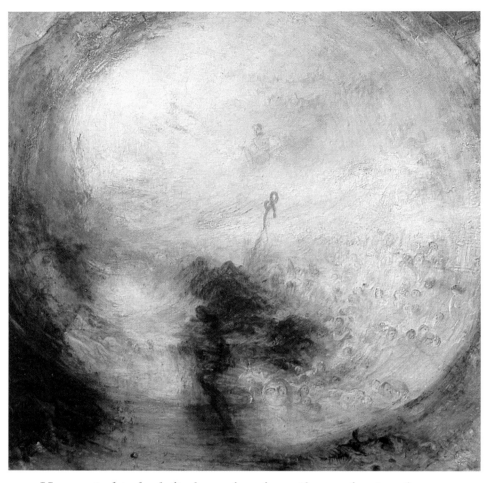

He wanted to be left alone, free from the professional pressures which his Academy status and success had created. He revelled in the changing times, in the industrial age. His great painting, *Rain, Steam and Speed – The Great Western Railway*, exhibited in 1844, reflects his acceptance of man's interference in nature. Wilton calls this painting 'an astonishing synthesis of Turner's passion for experiment and his love of the old masters, his commitment to classical landscape and his vivid response to the modern world'.

Turner's style had been adapted over the years to become less formulaic and more impressionistic. His genuine artistic integrity prevented him from painting commercial works, and he had found in his new techniques an ability to express the passion which scenes from nature continued to evoke within him. Eric Shanes writes:

> The artist's indistinctness, his complex meanings and his increasingly high-keyed colour ranges (especially his love of yellow) were not calculated to win the hearts, minds and eyes of the Victorians, who preferred verisimilitude to painterliness, sentimentality to academic idealism and saccharine colouring to the brilliant hues that Turner often presented to the eye.

But whatever the establishment had begun to think of Turner, they were stopped in their tracks by the inordinate energies and determination of Turner's personal champion, once again appearing in the form of John Ruskin.

Ruskin was an unusual and eccentric character. He was born in 1819 and had grown up in Herne Hill, a leafy suburb outside London, close to the Dulwich College Picture Gallery and near enough to London for him to experience the cultural events it had to offer. He did not attend school; instead a series of tutors and classes with his parents presented him with an unusual and varied education. By an early age he had become a highly regarded critic of art, championing in particular William Turner.

Peace – Burial at Sea, 1841 (Tate Gallery, London). This painting was undertaken as a tribute to his friend David Wilkie, who had recently died. The only source of light in the painting is the coffin, which is being lowered into the sea.

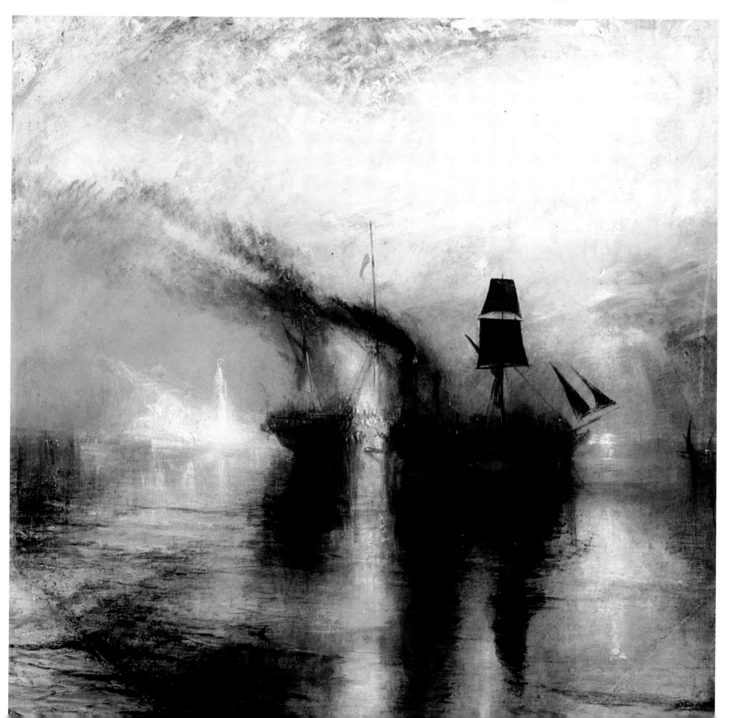

Timothy Hilton, in *The Pre-Raphaelites*, wrote:

Ruskin's early writing about nature, as in the first two volumes of
Modern Painters *(1843 and 1846) is highly personal as well as
precisely descriptive; and this is also true of his attitude towards
art. His criticism is most successful when the two are brought most
closely together. Turner's painting, for him, was beautiful because it
was true;* Modern Painters *... is largely given over to the expansion
of this idea. European painting of the post-Renaissance ... could not
be anything but loathsome. Claude, Poussin, the classical masters
of the landscape tradition ... the genre painters of the Dutch school
... are criticized with some vehemence, not as a man might kick
away the curs that snap at his heels, but exhaustively, at great
length ... with every instrument of castigation.*

View over an Alpine Valley (Private Collection). Turner returned repeatedly to the Swiss landscape throughout his career. It was these works which had attracted the attention of Ruskin, for whom Switzerland was very much a holy land. Spurred on by Ruskin's praise, Turner returned to Switzerland every year for four years after their meeting in 1840.

Ruskin believed implicitly in Turner's vision of art, and his *Modern Painters*, published between 1843 and 1860, was, strictly speaking, a five-volume tribute to Turner intended to prove that 'We have had, living amongst us and working for us, the greatest painter of all time.'

Turner was bemused by the attention, and certainly flattered. It is also likely that he agreed with Ruskin's opinions for he had returned to Switzerland for four consecutive summers, painting what most art critics agree to be his finest creations. In the Alps he found the comfort he had sought most of his life. The splendour of the natural world put his own life into perspective and the overwhelming fear of dying which had haunted him, as one by one his friends passed away, was somehow lessened here. To die, to return to the earth, to the fabulous energy that ran through nature, was somehow more appealing than the lonely life he had been leading. The sun, the source of all real light, became the focus of much of his work. There were four sets of watercolours which emerged from these visits, works which embody his mature talents and represent the fulfilment of his fundamental vision.

Funeral at Lausanne, 1841 (Tate Gallery, London). Turner painted this on the first of his return excursions to Switzerland. He found great comfort in the Alps, where he was able to come to terms with his own mortality. Turner lost a great number of his friends over these years, and his own fear of death had become overwhelming. The serenity of this painting confirms his acceptance of eventually becoming one with nature.

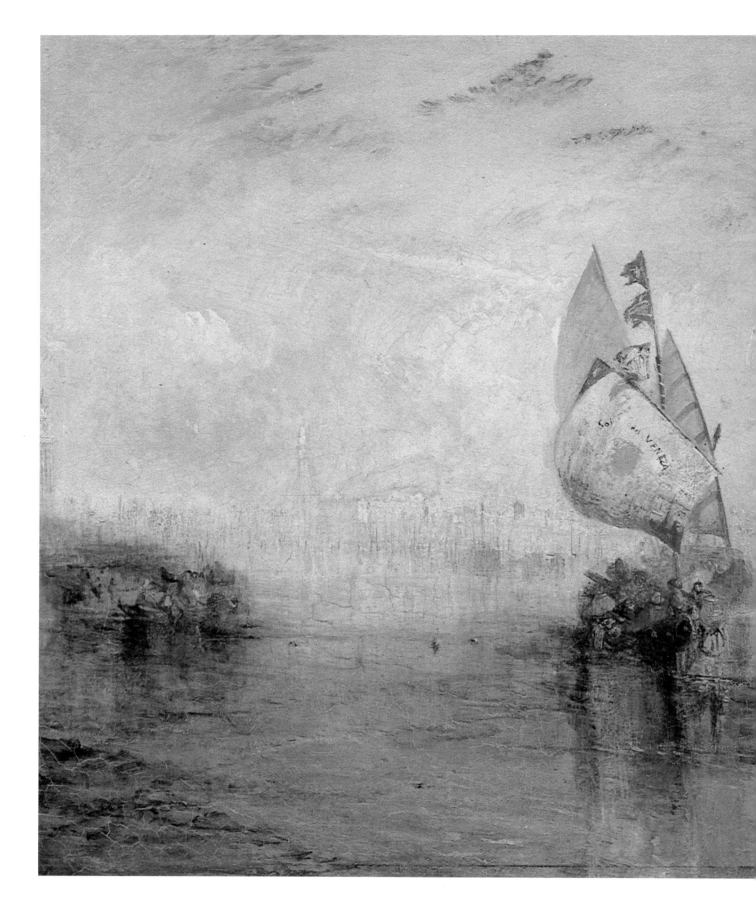

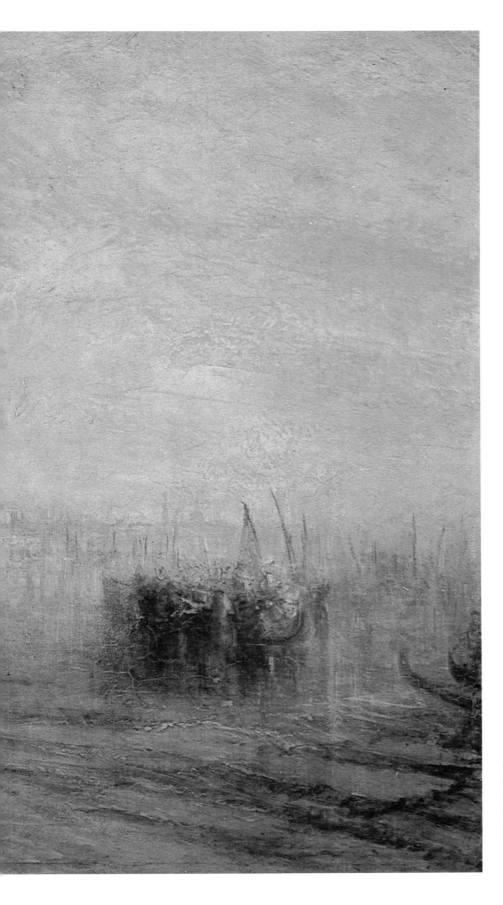

The Sun of Venice Going to Sea,
c. **1843** (Tate Gallery, London). This
painting vividly contrasts with *Venice,
Grand Canal*, which was painted just a
year earlier. He has moved away from
the Dutch influence in his marine work,
working with a warmer palette and less
decisive delineation.

The pictures are radiant, idealistic and supremely composed. Eric Shanes said that they were 'works in which light, colour and energy are all intensified to the utmost degree, dissolving forms in the process. These paintings do not celebrate merely the physical world: their pulsating energies, intensities of light and dissolutions of form are clearly expressions of something beyond'

Ruskin was fascinated, and as well as publishing his views on Turner's genius, he purchased a number of his works, creating for himself the role of patron and protector. Although Turner had avoided painting for contemporary taste, he did not hesitate to find ways in which to ensure that his art was lucrative. Ruskin in particular was horrified to discover that Turner expected him to *pay him to sketch* while travelling in Switzerland. He wrote, 'In the early Spring [1842] a change came over Turner's mind. He wanted to make some drawings to please himself; but also to be paid for making them.'

Turner was also trying to raise money in order to publish five engravings of what he considered to be his finest oil paintings, in particular *Mercury and Hersé* (1811), *Dido and Aeneas* (1814), *Crossing the Brook* (1815), *Juliet and Her Nurse* (1836) and *Caligula's Palace and Bridge* (1831). He somehow seemed to sense that his Swiss scenes were the

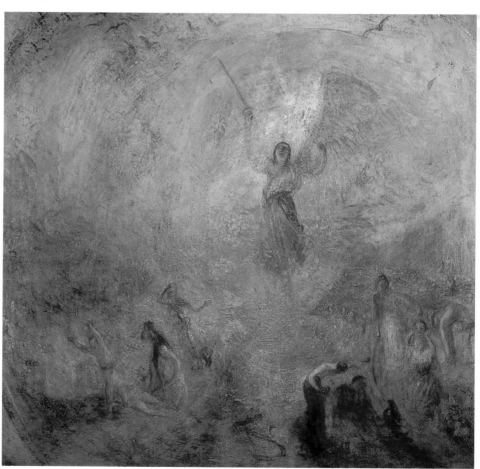

The Angel Standing in the Sun, 1846 (Tate Gallery, London). The subject of this painting may have been suggested by Ruskin, who called Turner the 'Angel of the Apocalypse' in a statement in *Modern Painters* which was removed before publication because of the implied blasphemy.

culmination of his talents in watercolour, and he wanted to ensure that his oil paintings were equally represented.

In 1845, Turner was made temporary President of the Royal Academy, when Sir Martin Archer Shee was unable to undertake his duties because of illness. It was a great honour and it came at a time when Turner knew his health was fading. He had continued to patronize the Academy for his entire career, exhibiting his work almost every single year. In 1850, just before his death, he fought against an illness which had left him with little control, and caused the loss of his teeth, and was able to produce four creditable paintings around the Dido and Aeneas theme. From there he settled down, and waited for the end.

Sophia had created a warm and welcoming home for Turner, with all his important belongings at his fingertips, and all his requirements satisfied. She often helped him to the roof of their house in Chelsea in order that he could watch the sun rise over the river. He had claimed proudly throughout his life that he had never missed the sunrise. For Turner, the Sun was God, not just a source of light or a useful motif. It

Plymouth Hoe, *c.* **1830** (Victoria & Albert Museum, London). This watercolour was undertaken for Turner's *Picturesque Views of England and Wales* – he has attempted to implement a wide variety of technical skills, in order to show his range of talents, but the painting, while refreshing and unassumingly gay, is rather clumsy in composition and coloration.

was fitting, somehow, that on the day he died, 19 December 1851, his attending doctor recalled that, 'On the morning of his decease it was very dull and gloomy, but just before 9 a.m. the sun burst forth and shone directly on him with that brilliancy which he loved to gaze on and transfer the likeness to his paintings. He died without a groan ...'

Whether or not Turner chose to believe it, the sun had shone on him for most of his life, providing him with inspiration, feeding his extraordinary talents, warming his cold and empty life whenever he allowed its rays to touch him. When he died he left a bequest to the nation: an estate valued at what would today be hundreds of millions of pounds, with nearly two thousand paintings and watercolours, twenty thousand sketches and drawings, and thousands of prints. The only provisions were that a gallery should be built to house his works and that the almshouse which he had envisaged be set up under a foundation known as Turner's Gift.

The will was contested by Turner's relatives. His money went not to the poor, but to his family. His pictures went to the nation, but no gallery was built to house them until 1987. His paintings are now housed in the Tate Gallery in London. It is fitting that their final home is on the Thames, Turner's beloved river, dappled today by the same sunlight that shone on his genius all those years ago.

Detail from **Skeleton Falling off a Horse**, *c.* **1830** (Tate Gallery, London). Turner painted a dance of death theme many times in his *oeuvre*. The coloration is spectacular – pure white bursting into yellow and intense, bloody reds. This is a violent work, emblematic of Turner's obsession with death, and inspired, perhaps by West's *Death on the Pale Horse.*

INDEX

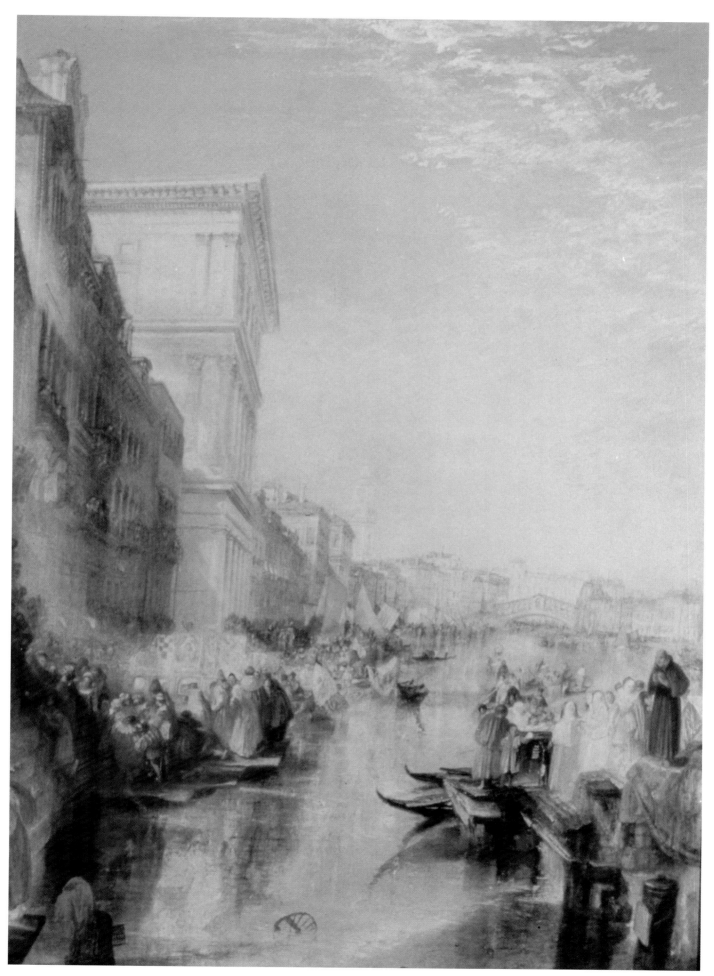

Turner. Venice, Grand Canal, *c.* 1842
(Huntington Library)

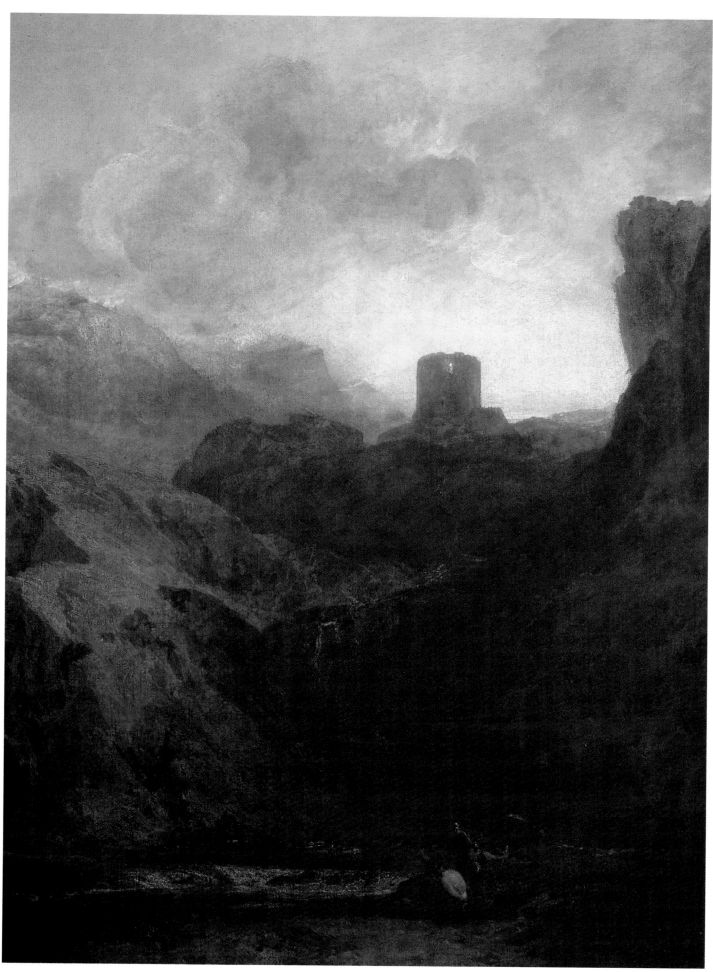

Turner. Dolbadern Castle, North Wales, 1800
(British Museum, London)

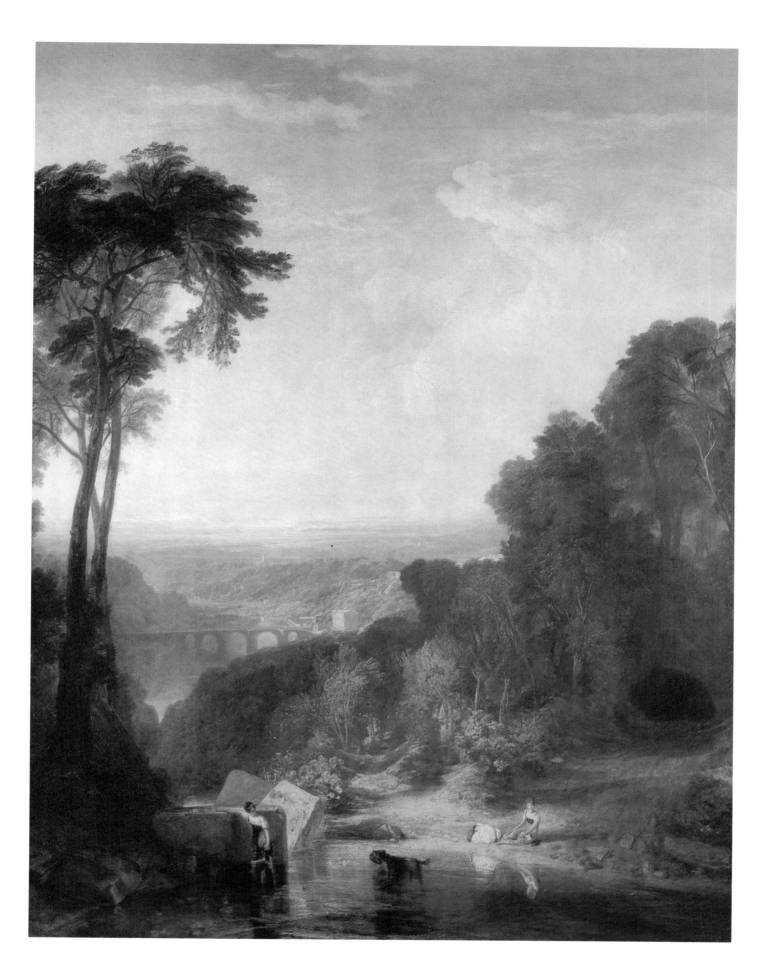

Turner. Crossing the Brook, 1815
(Tate Gallery, London)

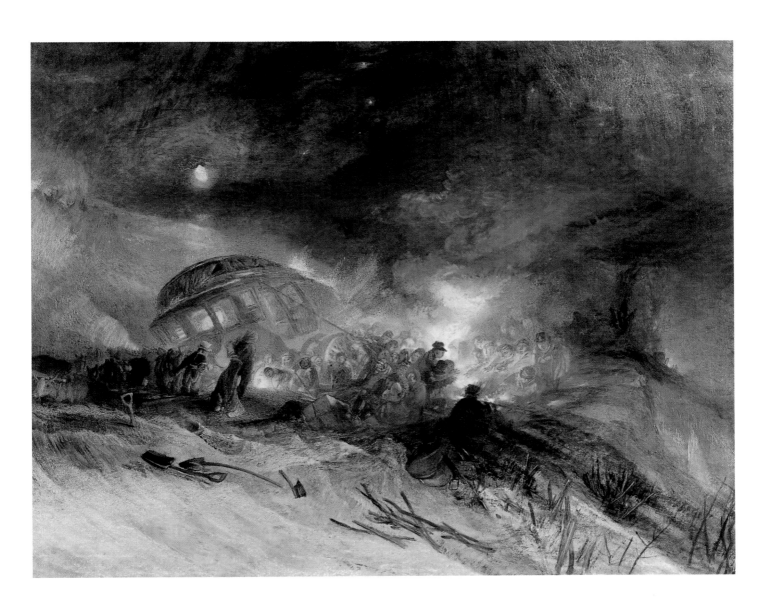

Turner. Messieurs Les Voyageurs on their Return from Italy ... , 1829
(British Museum, London)

Turner. Rain, Steam and Speed – The Great Western Railway, 1844
(National Gallery, London)

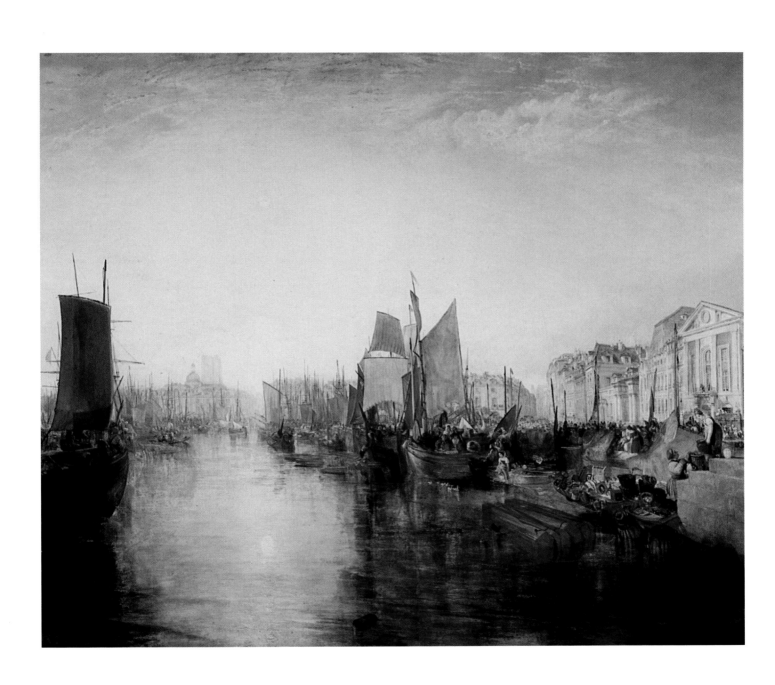

Turner. The Harbour of Dieppe, *c.* **1826**
(Frick Collection, New York)

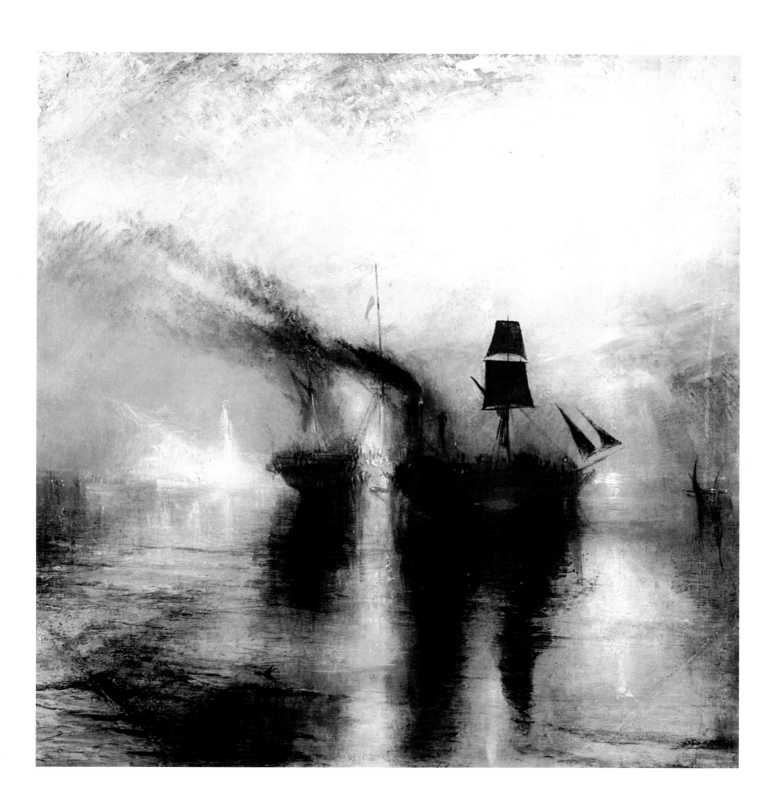

Turner. Peace – Burial at Sea, 1841
(Tate Gallery, London)

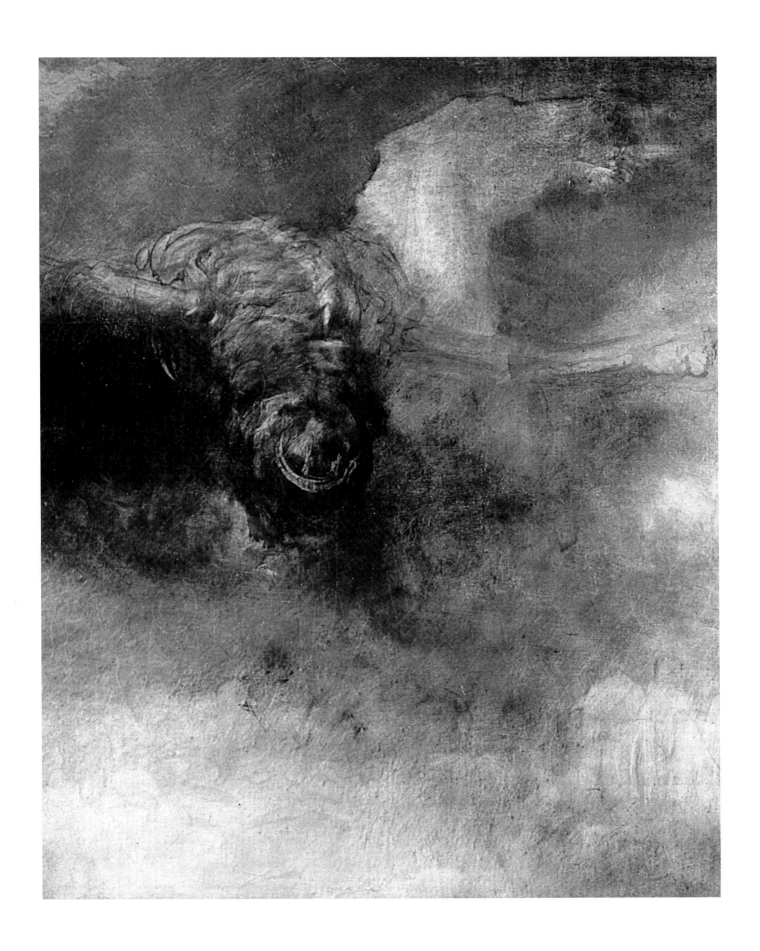

Turner. Skeleton Falling off a Horse, *c.* 1830
(Tate Gallery, London)